THE
LOBSTERING
LIFE

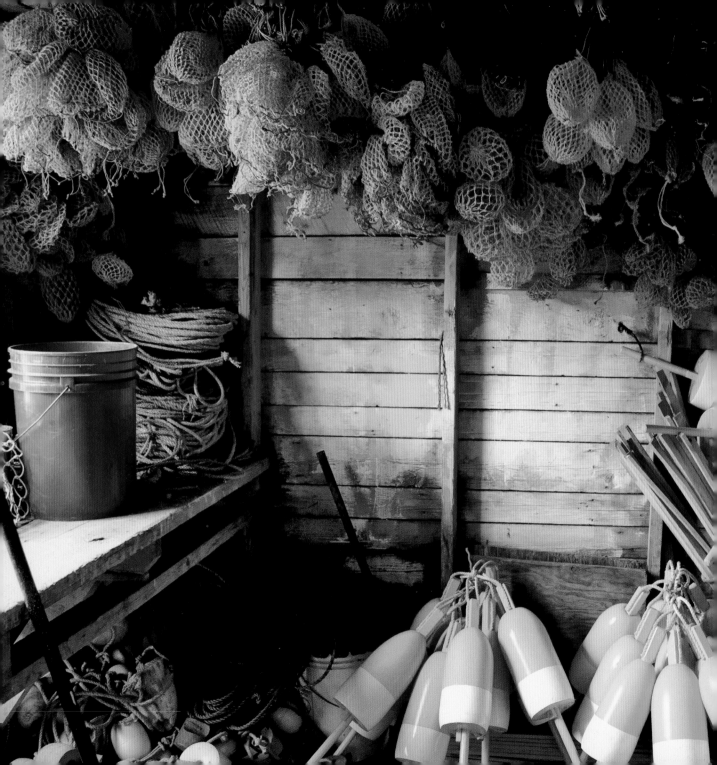

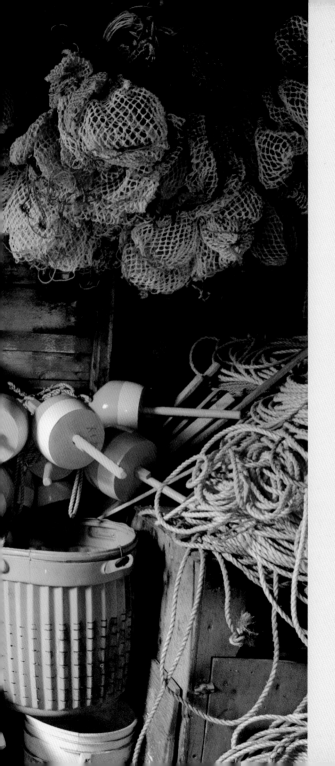

THE LOBSTERING LIFE

**DAVID MIDDLETON
AND BRENDA BERRY**

THE COUNTRYMAN PRESS
Woodstock, Vermont
www.countrymanpress.com

ACKNOWLEDGMENTS

Randy Anderson
Ed Aranza
Mark Austin
Barney Cove Lobster Co.
Rick, Dave, and Clyde Barrow
Joan Beale
Stanley Beale
Stanley Beckman
Arnold Benner
Chris Bruce
Chris Cash
Beth Casoni
The Ciomei family
Norm Closson

Cohasset Lobster Pound
Bill Coppersmith
Trevor Corson
Douglas Dodge
Phil Frost
Carrie Gleason
Andrew and Ruth Gove
Melissa Gray
Greenhead Lobster Co.
Bobby Healy
Mel Hutchinson
The Island Institute
Steve Johnson

Greg Jordan
Donny McHenan
Sal Lupo
Tom Lupo
Jason McDonald
Mount Desert Oceanarium
Alex Orne
Dewy Painton
Steve Ragusa
Red's Eats
Steve Robbins II
Steve Robbins III
Jim Sanders

Sanders Lobster Co.
Robert Stanley
Sherm Stanley
Stonington Co-Op
Beth Storey
The Thompson family
Thurston's Lobsters
Dana Tolman
Roxie Tolman
Richie Walker
The Whitaker family
Young's Lobster Pound
Wayne Young

Special thanks to Steve Robbins III for his unending patience and support.
Brenda thanks David Middleton for being a true collaborator and friend.
Most of all we would like to salute and thank all the fine lobster fishermen
who gladly answered our questions and graciously tolerated our cameras.

———————————————————

Book design and composition by Eugenie S. Delaney

Published by The Countryman Press, P.O. Box 748, Woodstock, VT 05091
Distributed by W. W. Norton & Company, Inc., 500 Fifth Avenue, New York, NY 10110
Printed in China

10 9 8 7 6 5 4 3 2 1

The Lobstering Life
978-0-88150-939-7
Library of Congress CIP data have been applied for.

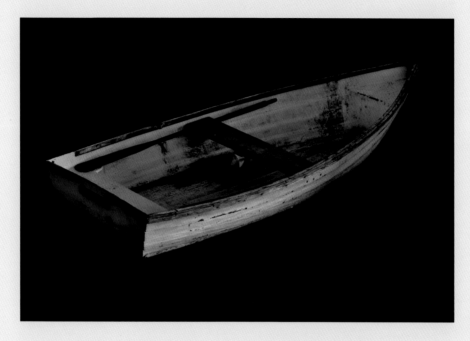

For the keepers of our hearts and homes.

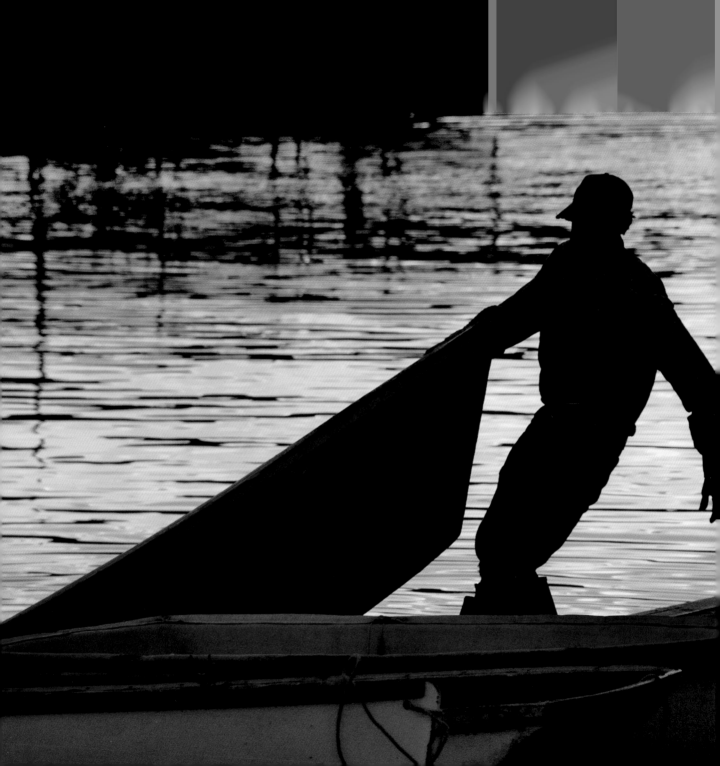

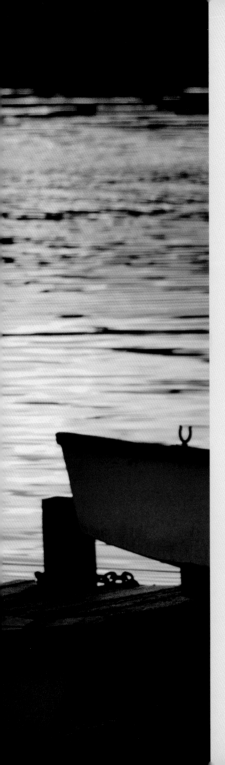

CONTENTS

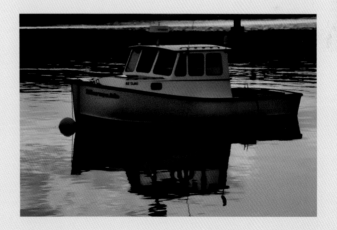

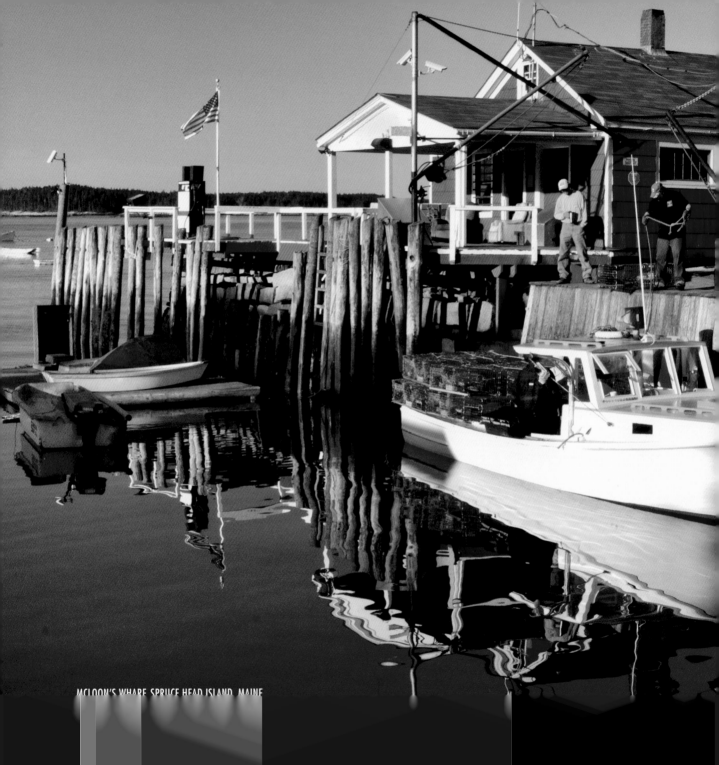

MCLOON'S WHARF SPRUCE HEAD ISLAND, MAINE

INTRODUCTION

"Mawnin'."
"Mawnin'."
"Gawdam Sox."
"Ah-yep."

AS CAPTAIN AND CREW MEET ON THE DOCKS, day begins to dawn, a slow prelude to the growing rhythms of another day spent catching lobsters.

There is little time to linger. The boat must be fueled, bait must be loaded. A hole $500 dollars deep is dug before they've even cleared the jetty. In the growing dawn there's bait to prepare, gear to prep, and thoughts of rest to stow away for later. The boat will be back in 12 hours or so—catch unloaded, gear cleaned, deck readied for the next day—but before then a thousand lobsters or more will cross the gunwale and all hands will be busy.

There are 130 million lobsters crawling the sea floor of the Gulf of Maine. Over 60 million pounds are brought ashore each year to fill plates around the world. But with prices low and costs high, lobstermen still have to fight the tides every day and keep hauling to get ahead. If a lobsterman or -woman is just out, as they say, changing the water in the traps or restocking the snack bar, the boat will be up on blocks in the back yard before the summer tourist crush.

"We'll be steamin' nawth. Haul the outside string first."
"Back before the game stawts?"
"A-yep."
"Gawdam Sox."

Lobstering is a dance stepped across the seasons on a dance floor submerged and dark and crawling with life. Each month the dance floor moves, sometimes farther out and sometimes nearer shore; sometimes to rocky ground and sometimes to mud. And every day, sometimes every hour, the tempo changes as the sea shifts from a warm embrace to a cold slap in the face.

But the steps of the dance are always the same—haul, pick, bait, set—all day, every day, over months, years, and generations. It is not the dance of young lovers, tentative and slow. It is the hard-work dance of thousand-horsepower boats—rolling, bucking, smashing the waves, pulling up paychecks from the cold dark sea. It is the tough, stubborn work of tough, stubborn people. It is the lobstering life.

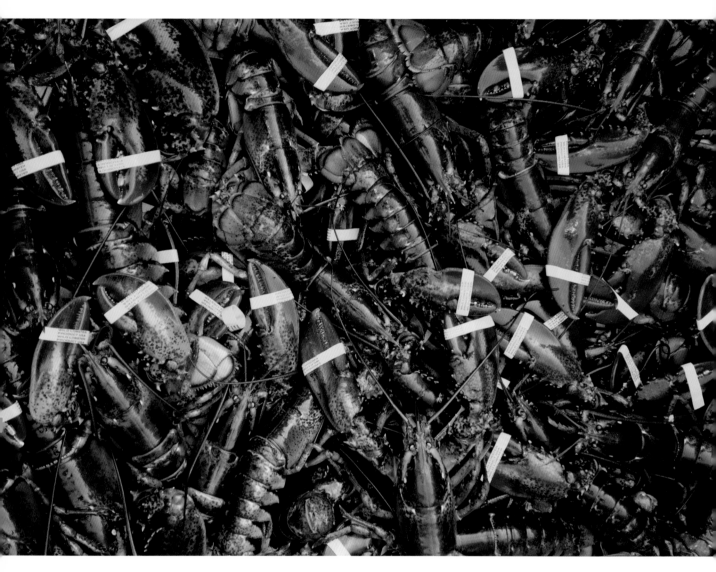

LOBSTERS FRESH OFF THE BOAT

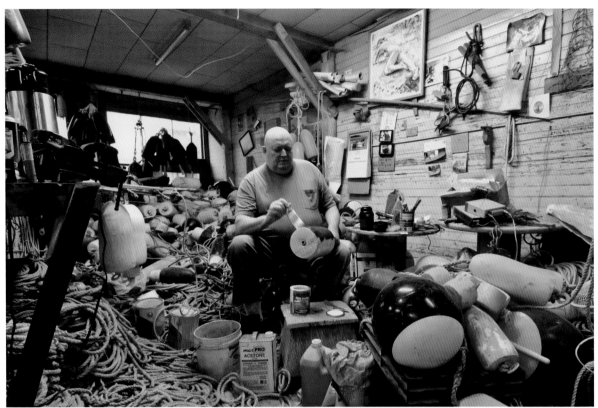

A LOBSTERMAN'S
WORK IS NEVER DONE,
STONINGTON, MAINE

BAIT BARRELS
IN WINTER,
NEW HARBOR, MAINE

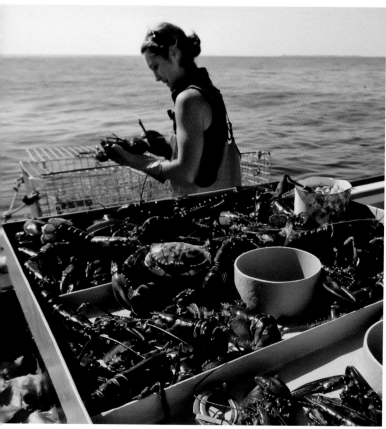

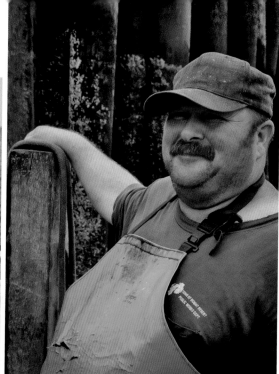

Above left: CHECKING FOR KEEPERS
ON PENOBSCOT BAY, MAINE

Above right: A STERNMAN WAITS FOR
BAIT AND DIESEL BEFORE STEAMING OUT

Below right: A FUTURE LOBSTER-
BOAT CAPTAIN TAKES THE WHEEL

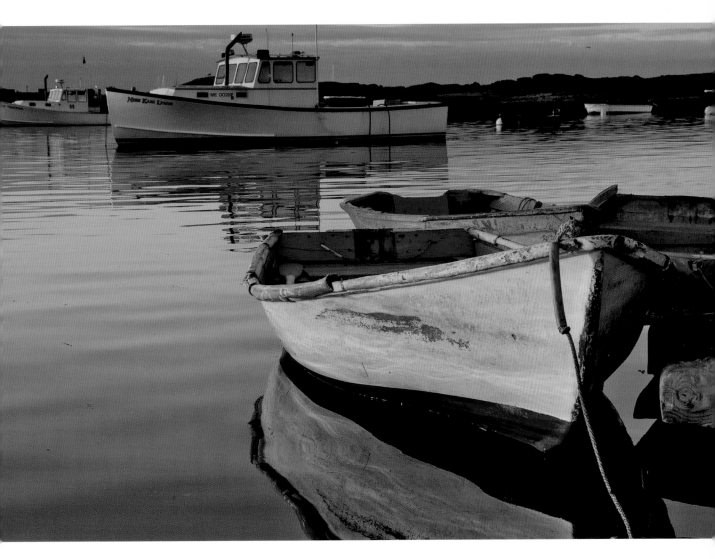

DAWN ON BASS HARBOR, MAINE

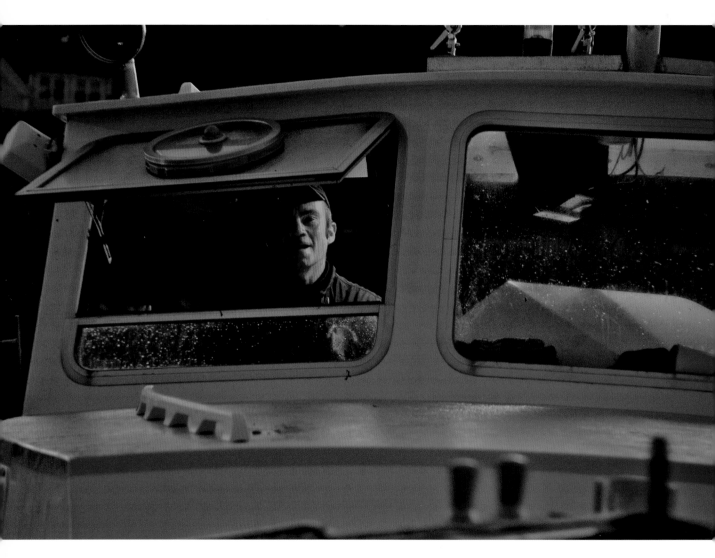

CAPTAIN OF THE *CAROL ANN*

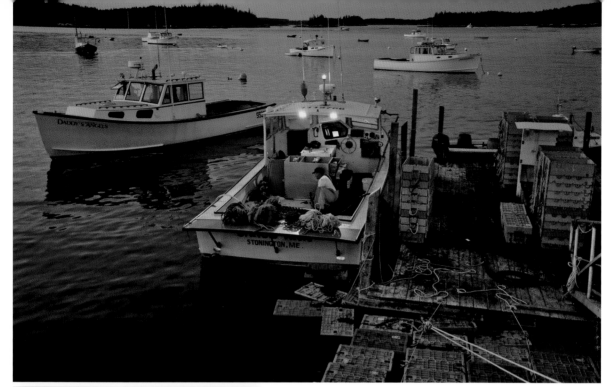

LOBSTER BOATS QUEUING UP
FOR BAIT AND FUEL AT DAYBREAK,
STONINGTON, MAINE

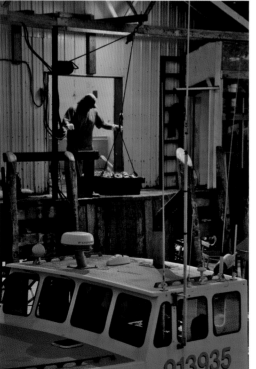

LOADING BAIT BEFORE DAWN

A RARE SIGHT—WOODEN LOBSTER TRAPS, YARMOUTH, NOVA SCOTIA

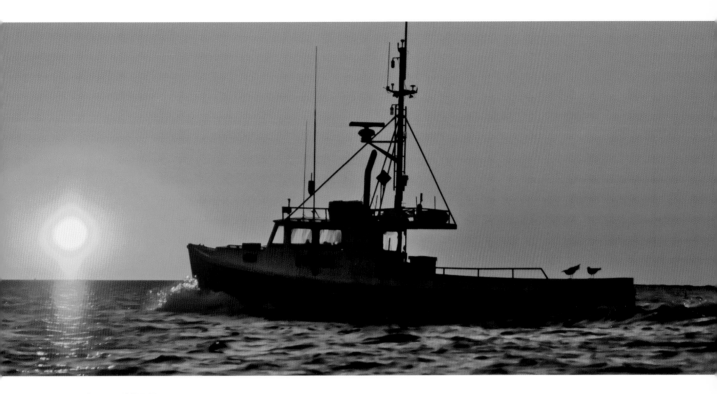

STEAMING OUT AT SUNRISE

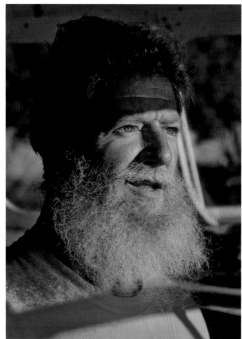

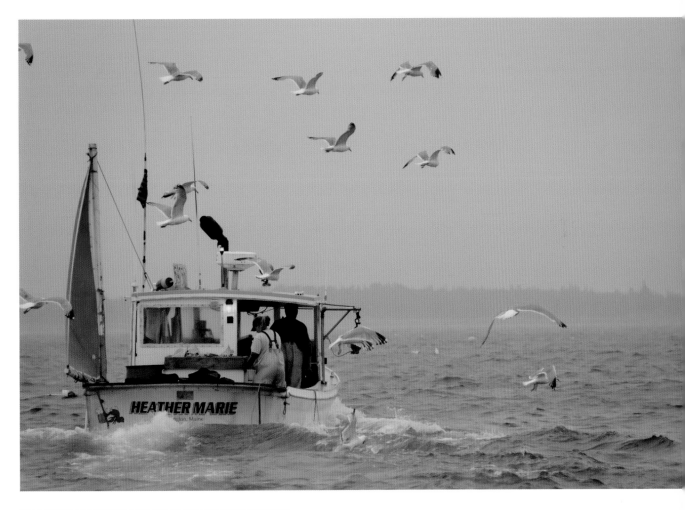

THE *HEATHER MARIE* AT SEA WITH ISLE AU HAUT IN THE BACKGROUND

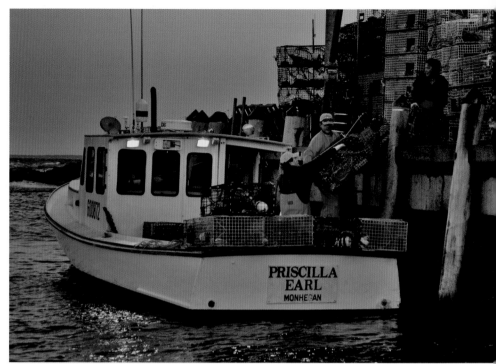

Right: LOADING THE
PRISCILLA EARL ON TRAP DAY

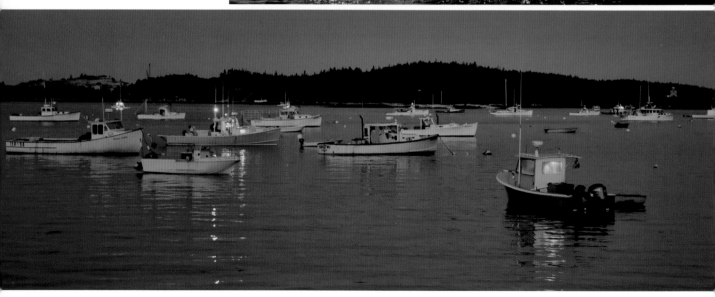

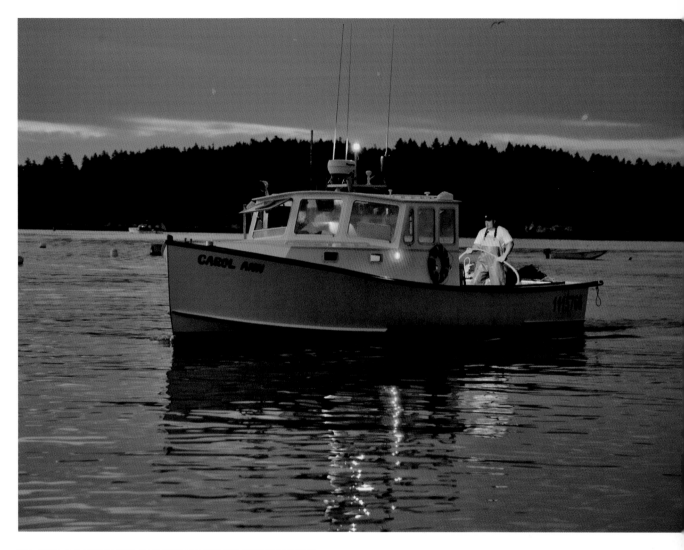

THE *CAROL ANN* COMING IN TO LOAD BAIT AND FUEL FOR THE DAY'S FISHING

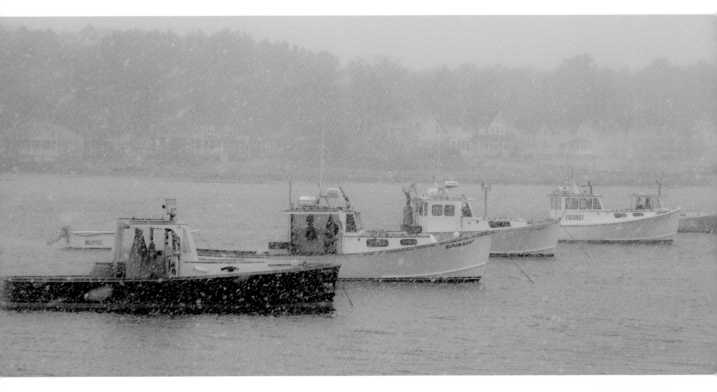

WINTER STORM, CAPE PORPOISE, MAINE

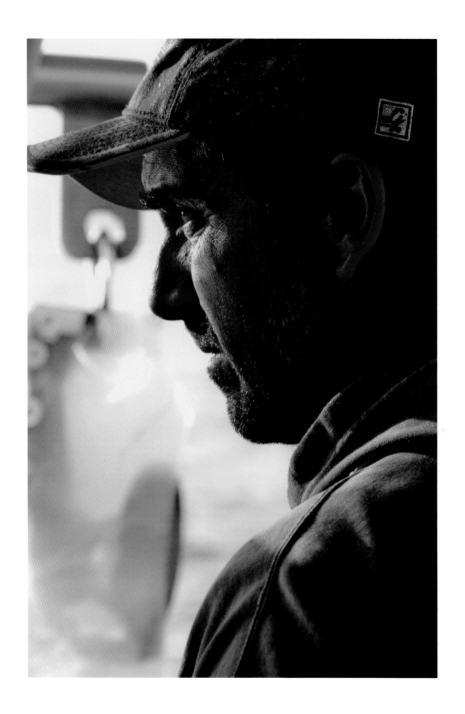

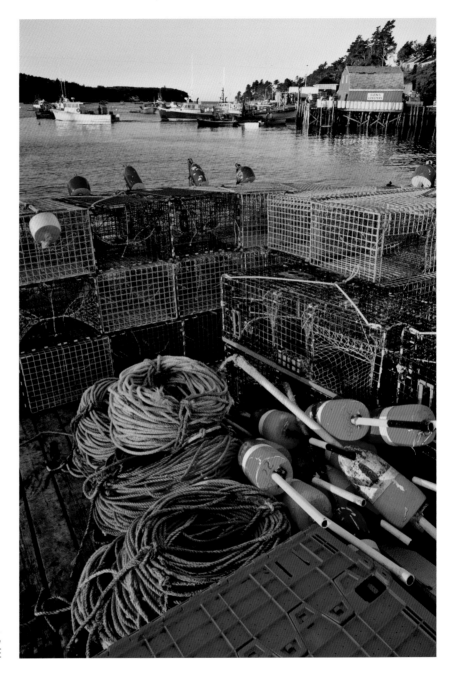

GEAR ON FLOAT,
MACKEREL COVE, MAINE

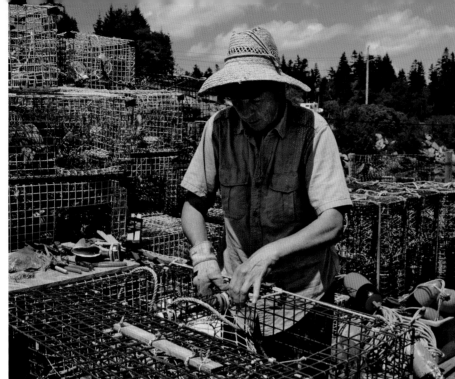

ADDING THE NEW
SEASON'S COLORED
IDENTIFICATION TAG
TO THE TRAPS,
BEALS ISLAND MAINE

TRIMMING THE TRAP RAILS

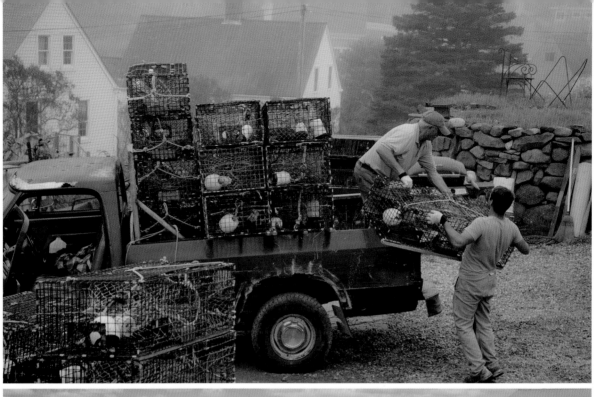
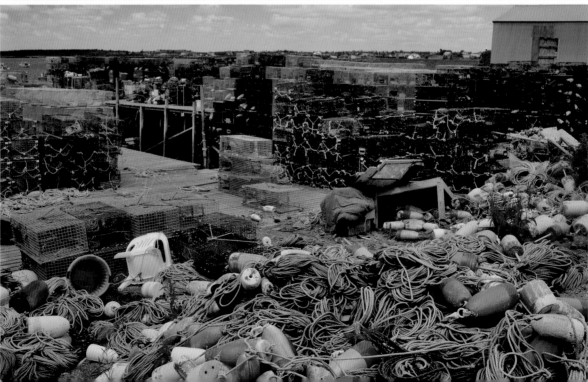

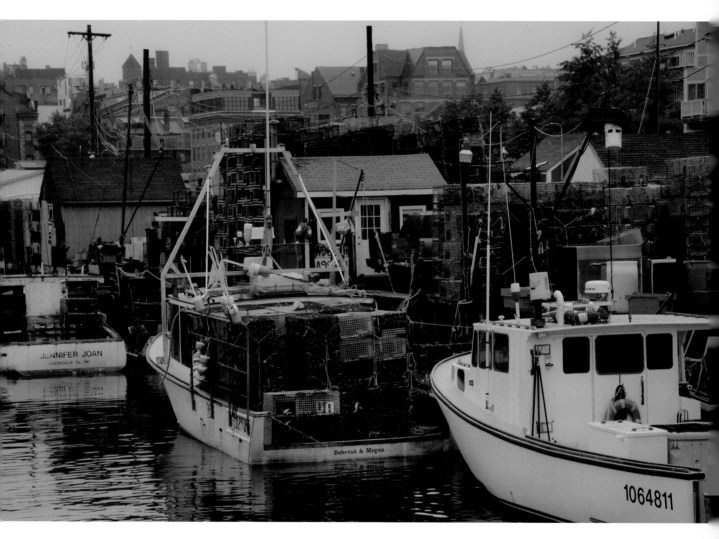

Above: THE PORTLAND WHARF WITH THE CITY IN THE BACKGROUND

Opposite above: LOADING THE TRUCK ON TRAP DAY, MONHEGAN ISLAND, MAINE

Opposite below: PILES OF GEAR WAITING TO BE USED, BEALS ISLAND, MAINE

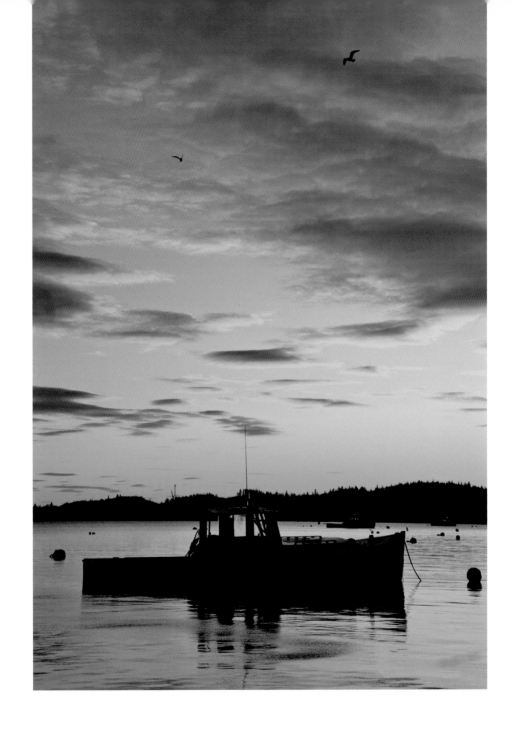

Above: STEAMING OUT AT DAWN

Opposite: SUNSET ON DEER ISLE

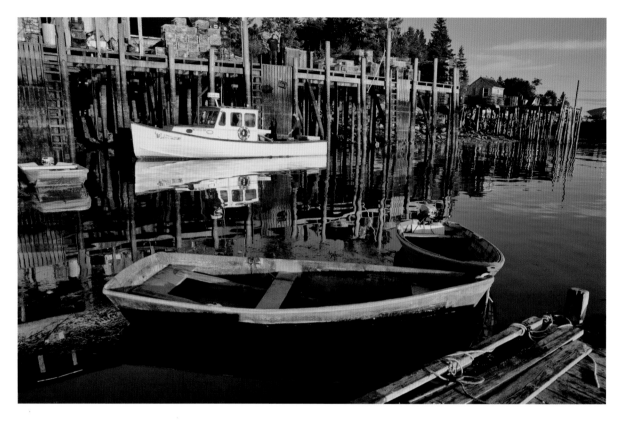

Above: THURSTON'S WHARF, BERNARD, MAINE

Opposite above left: CAPTAIN'S HAND ON THE THROTTLE

Opposite far right: READYING THE BOAT FOR ANOTHER DAY AT SEA

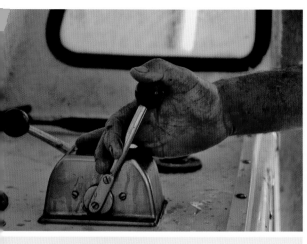

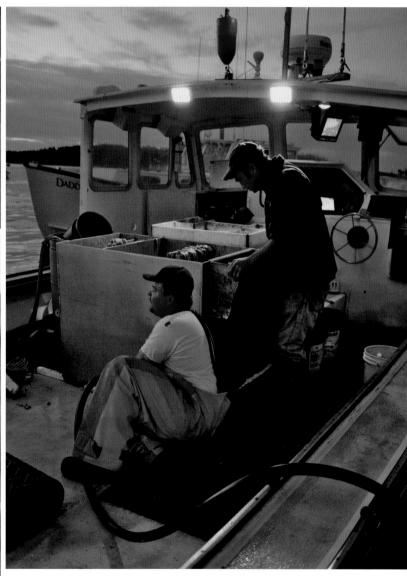

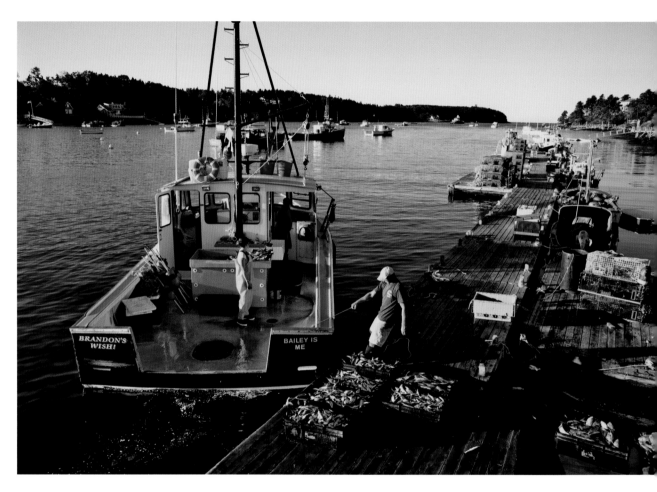

BACKING AROUND TO LOAD BAIT, BAILEY ISLAND, MAINE

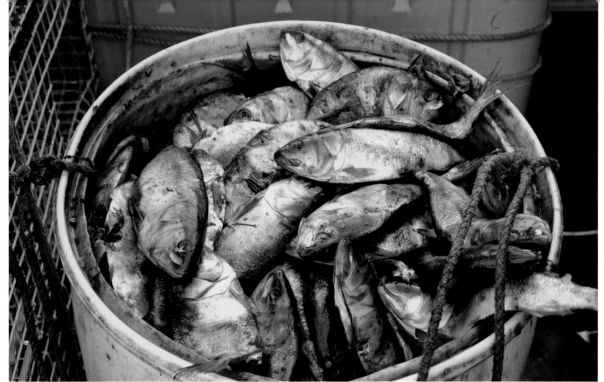

Above: BAIT BARREL

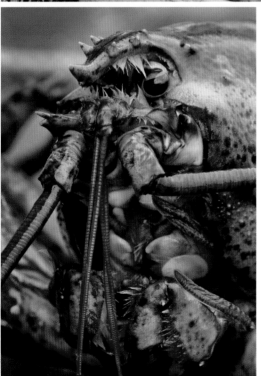

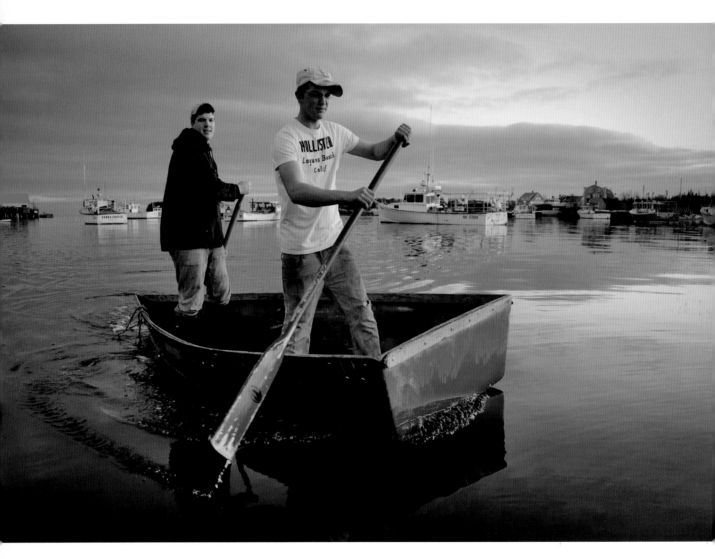

COMING HOME AT THE END OF THE DAY, COREA, MAINE

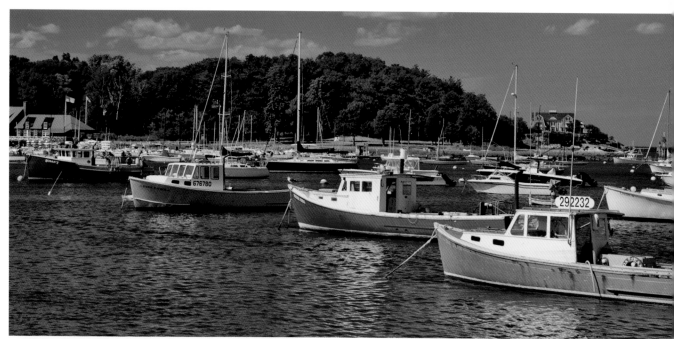

Above: **SUMMER IN COHASSET HARBOR, MASSACHUSETTS**

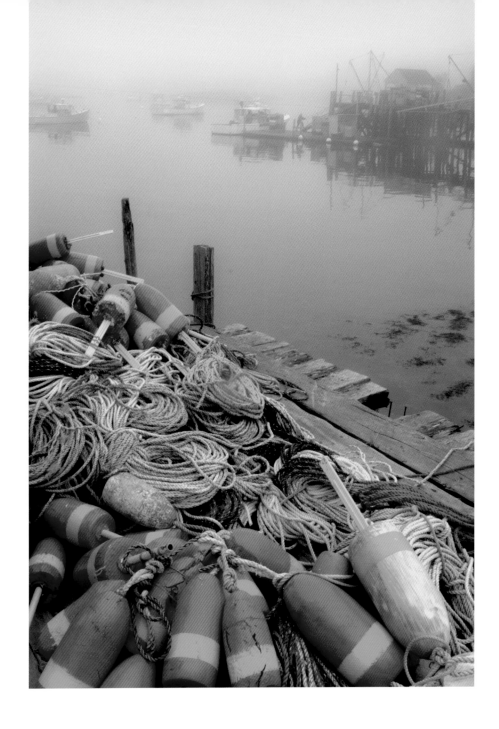

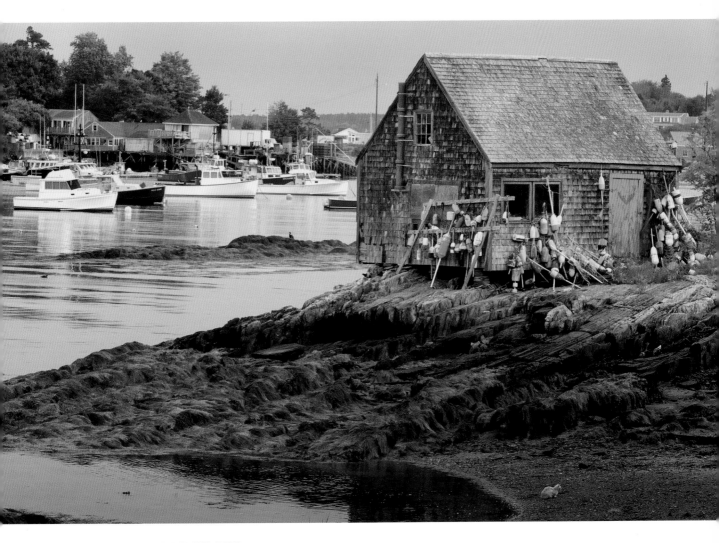

Above: LOBSTER SHACK, MACKEREL COVE, MAINE

Opposite: PORT CLYDE, MAINE

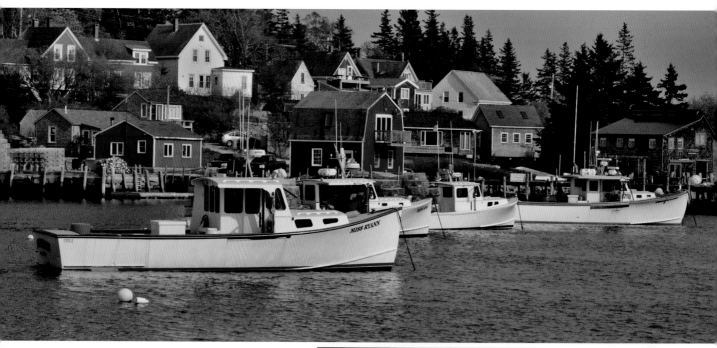

VINALHAVEN, MAINE

BASS HARBOR
CAPTAIN AT THE HELM

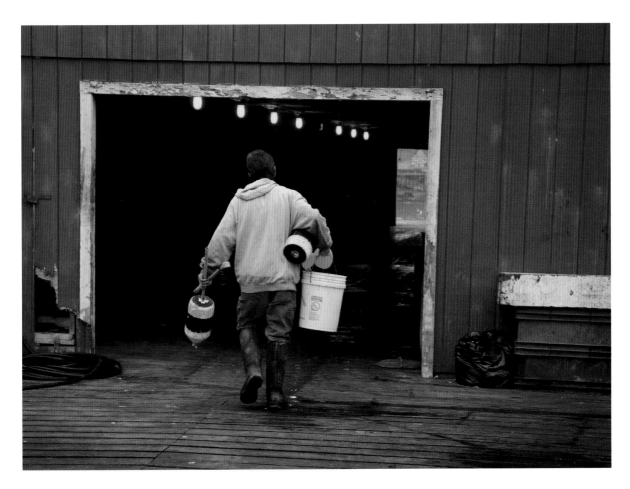

HEADING TO WORK

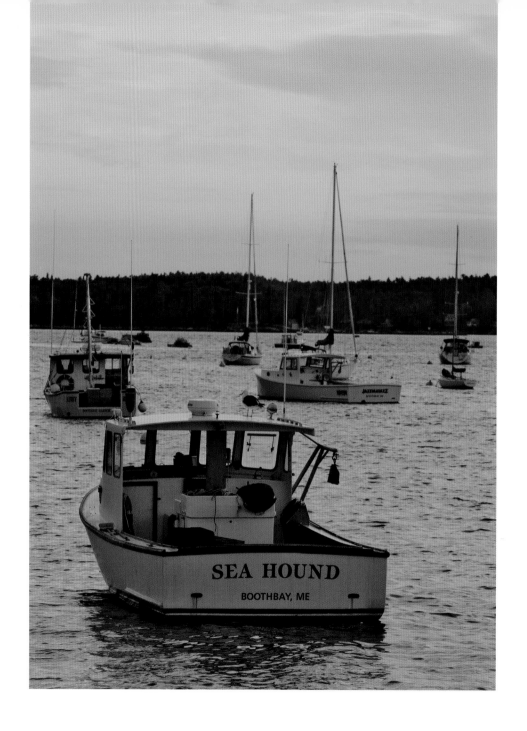

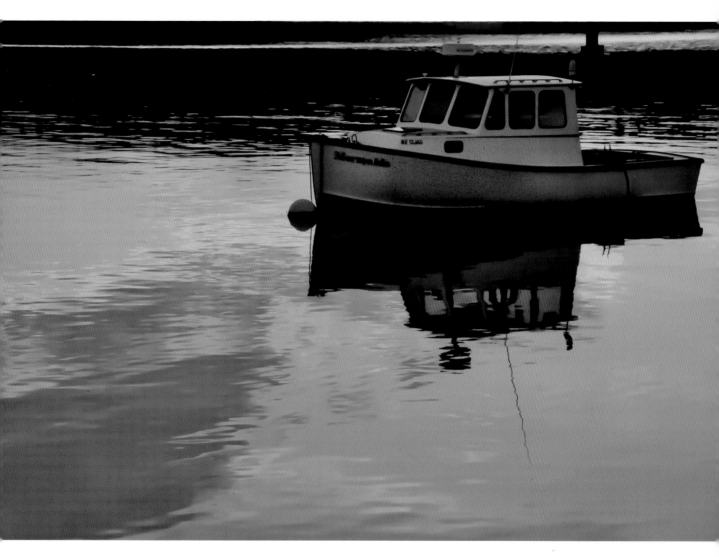

Above: AT ANCHOR, LATE EVENING, SOUTHWEST HARBOR

Opposite: BOOTHBAY HARBOR, MAINE

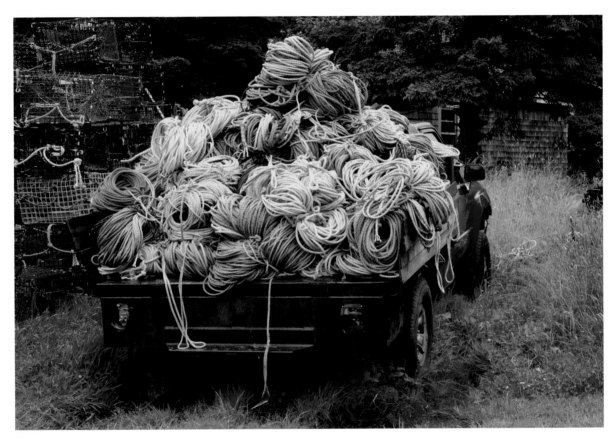

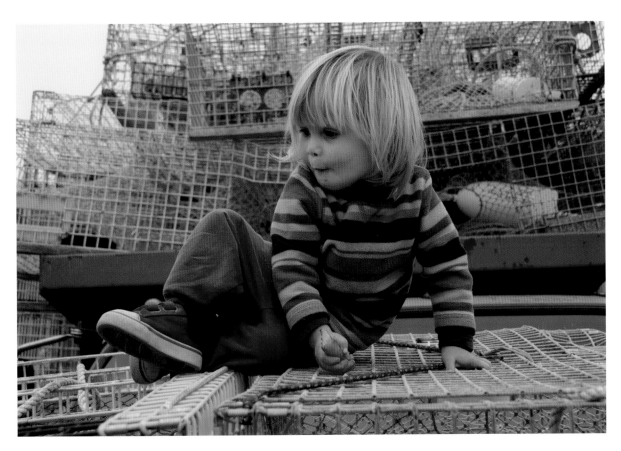

A LITTLE LOBSTERMAN CHECKS DAD'S TRAPS, MONHEGAN ISLAND, MAINE

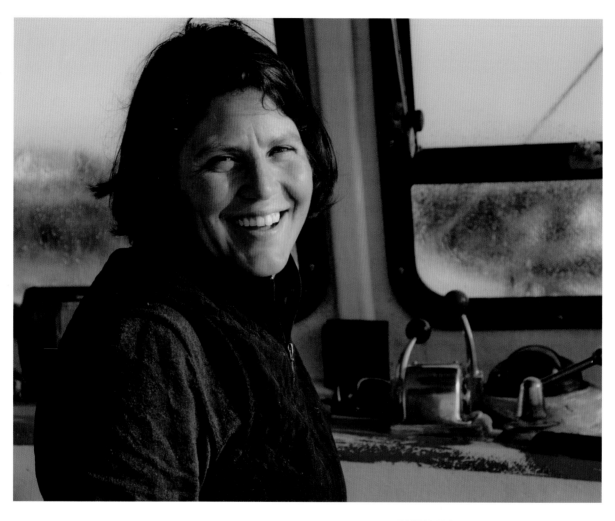

MONHEGAN ISLAND LOBSTER CAPTAIN AT THE WHEEL

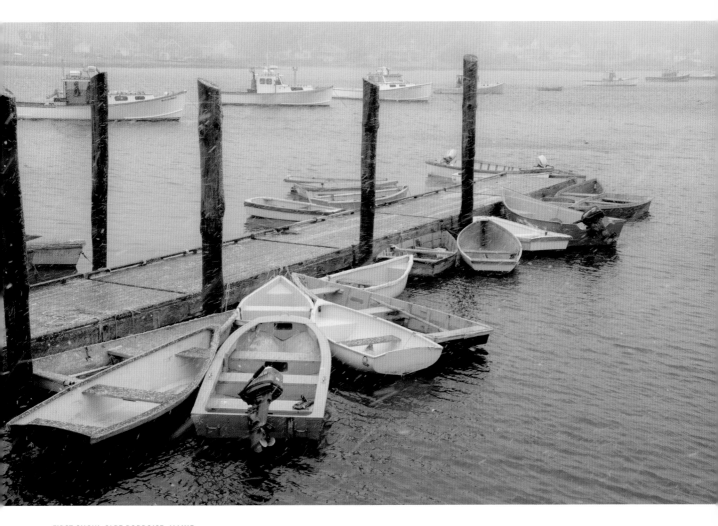

FIRST SNOW, CAPE PORPOISE, MAINE

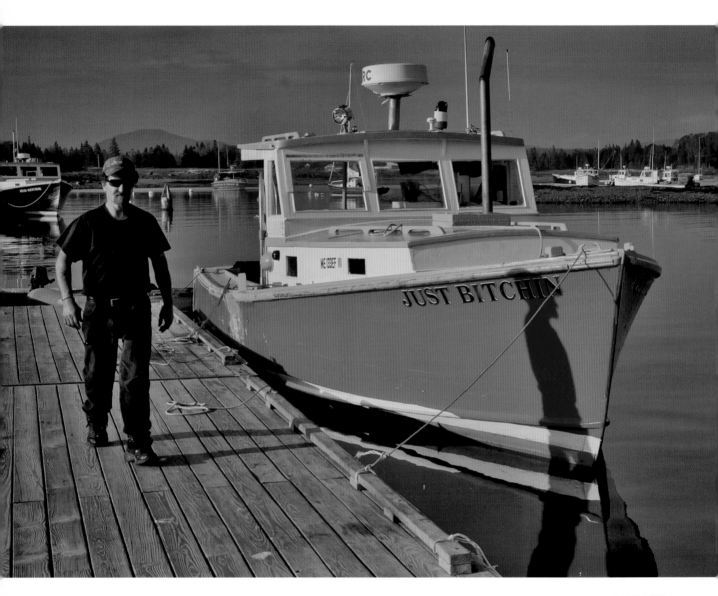

CALL IT A DAY

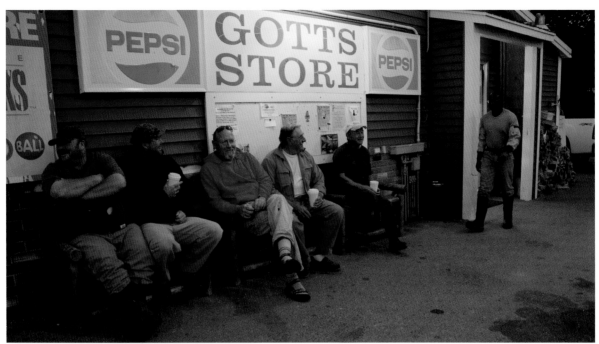

Above: THE 5 AM LOBSTER GANG STARTING THE DAY

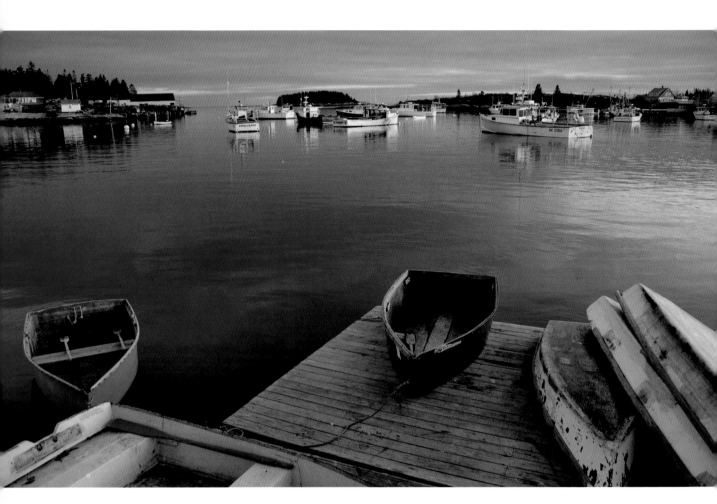

QUIET EVENING, COREA HARBOR, MAINE

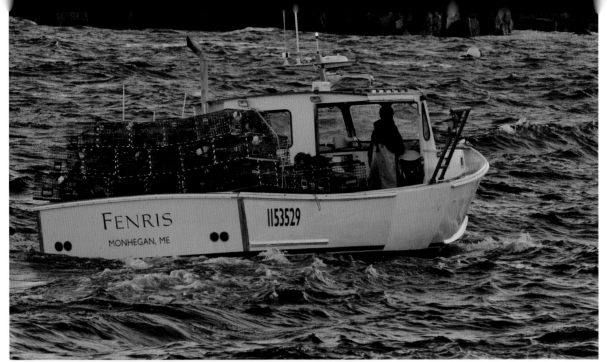

SETTING TRAPS AT FIRST LIGHT

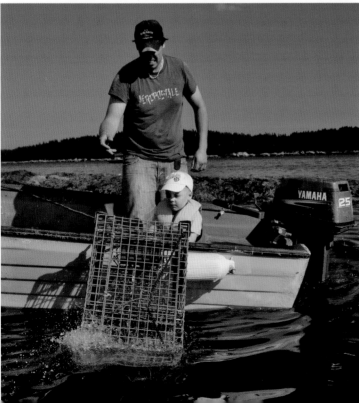

SETTING OUT AND STARTING YOUNG

49

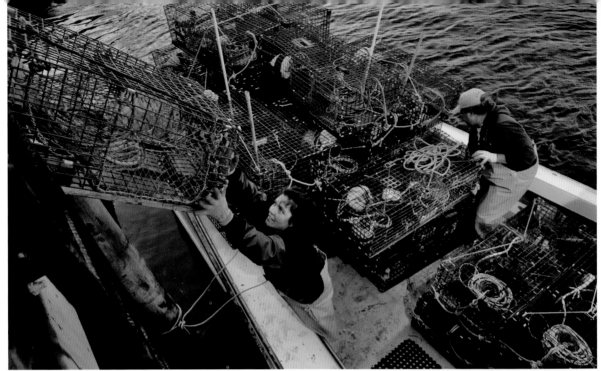

Above: LOADING TRAPS ON BOARD FOR THE FIRST SET OF THE SEASON

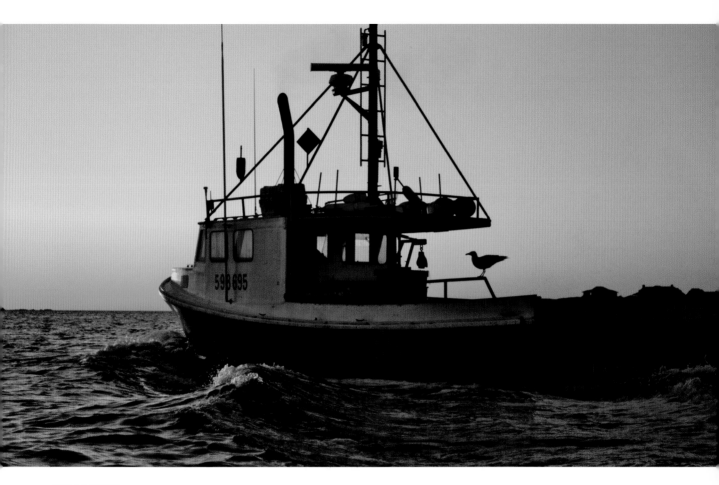

GULL ON BOARD!

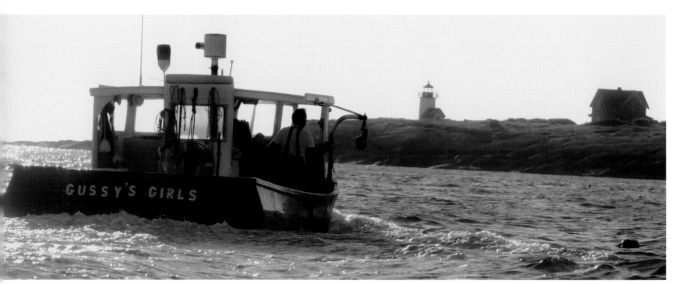

STEAMING TOWARD
ANOTHER SET OFF
STRAITSMOUTH ISLAND LIGHT,
ROCKPORT,
MASSACHUSETTS

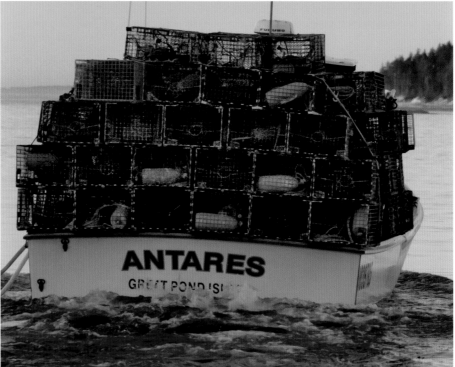

THE *ANTARES* SETTING
OUT OF SEAL HARBOR
WITH A FULL LOAD

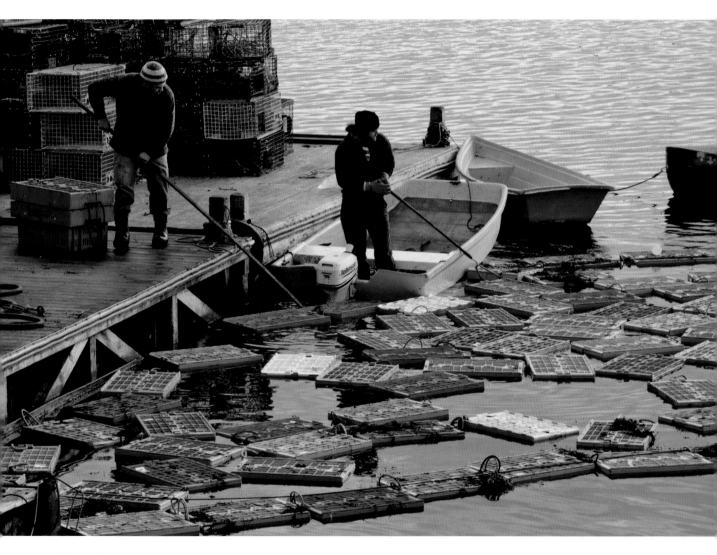

SORTING HOLDING CRATES FULL OF LOBSTERS, DEER ISLE, MAINE

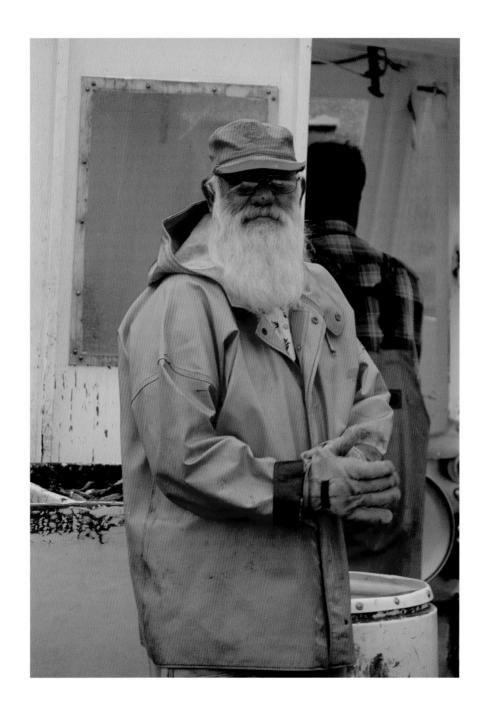

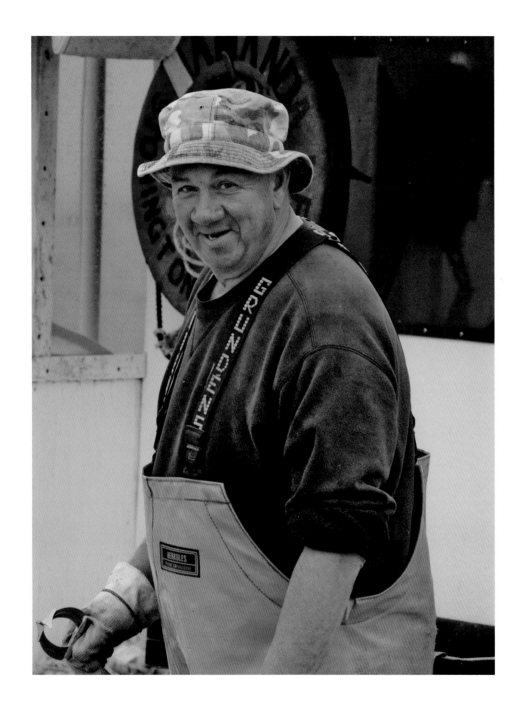

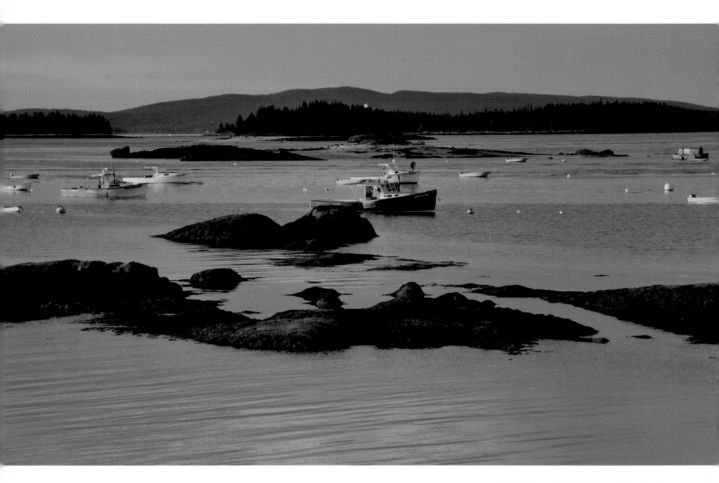

EARLY MORNING, DEER ISLAND THOROFARE

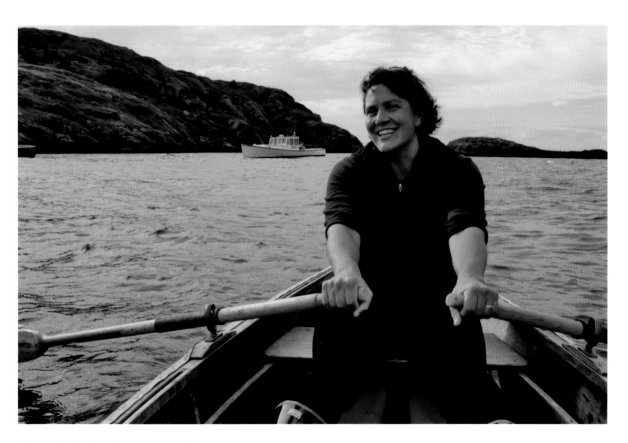

ROWING OUT ON MONHEGAN ISLAND, MAINE

LONGTIME
DEER ISLE
LOBSTERMAN IN A
QUIET MOMENT

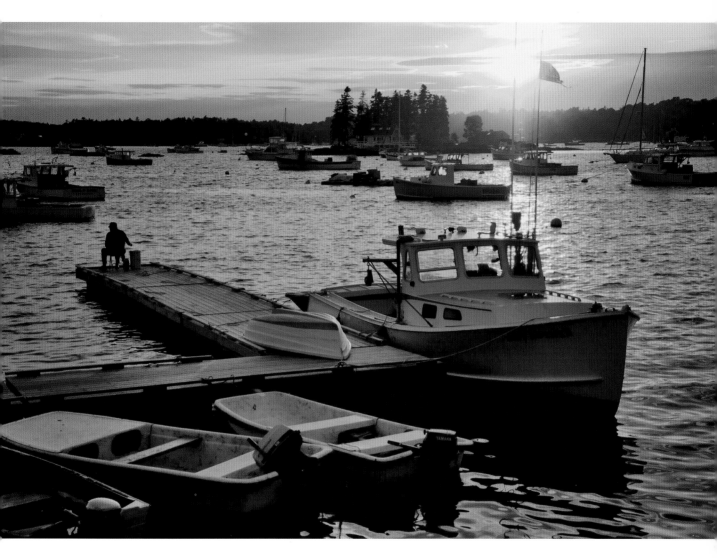

BOOTHBAY HARBOR, MAINE

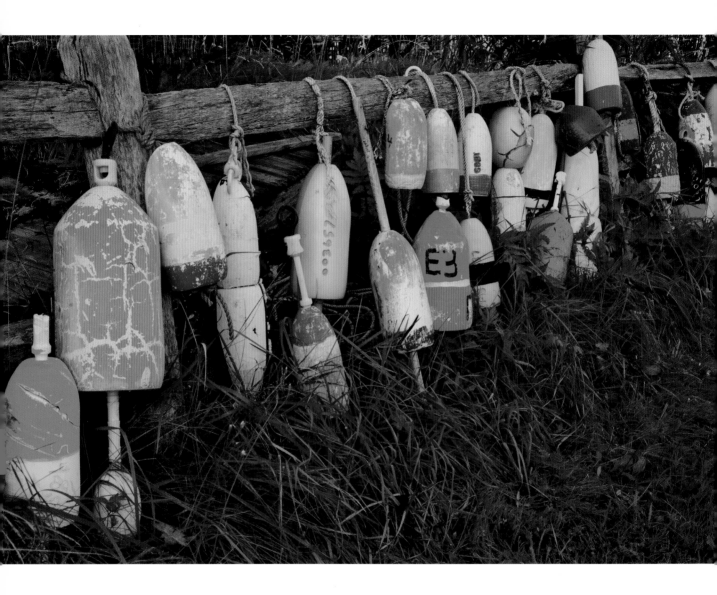

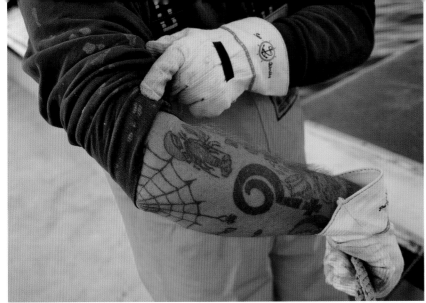

Left: A LOBSTERMAN'S ARTSY FOREARM

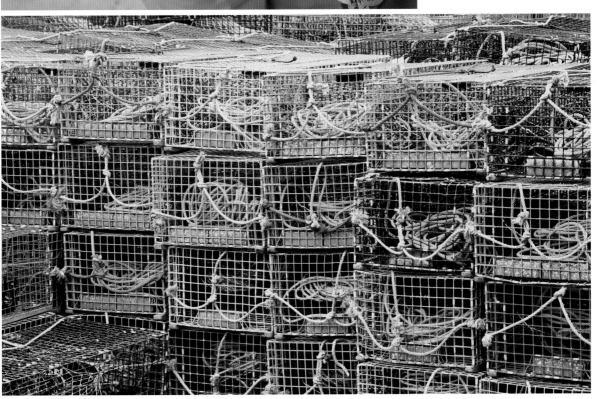

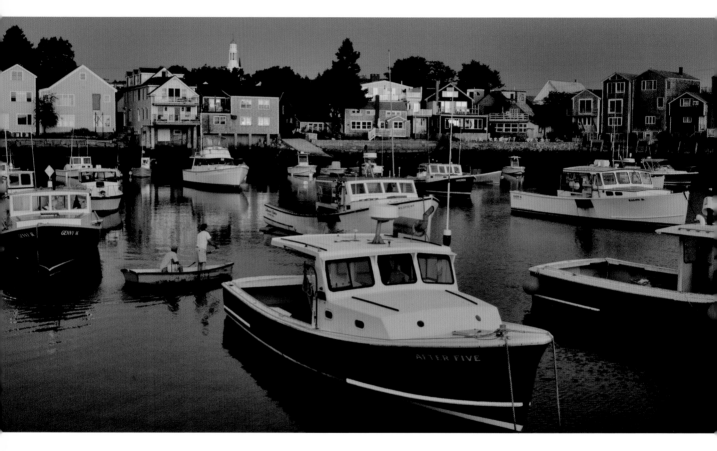

Above: PREDAWN IN ROCKPORT, MASSACHUSETTS

Opposite: PAINTING BUOYS AT SEASON'S END

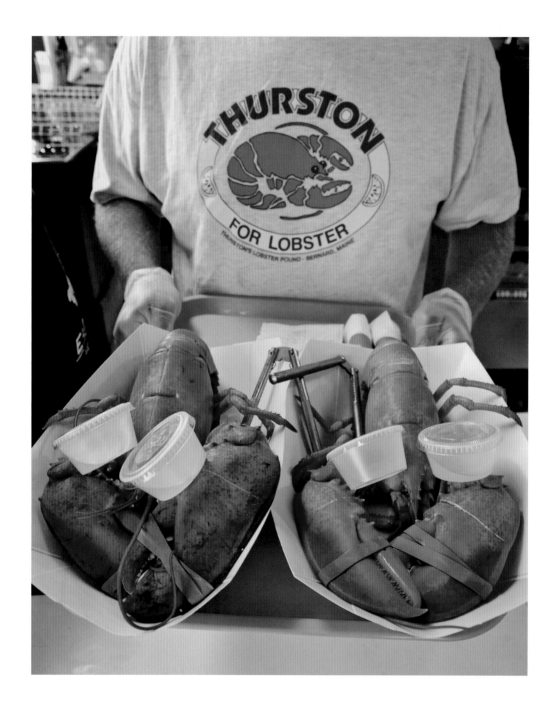

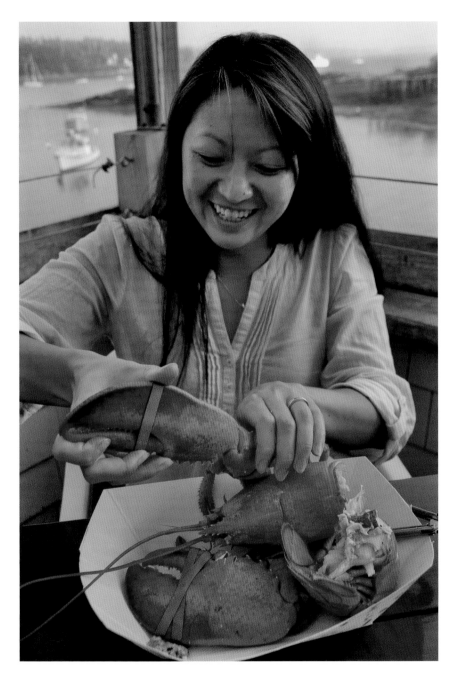

Left: THE FINAL STEP: ENJOYING
A LOBSTER DINNER AT THURSTON'S
LOBSTER POUND, BERNARD, MAINE

Opposite: DINNER FOR TWO!

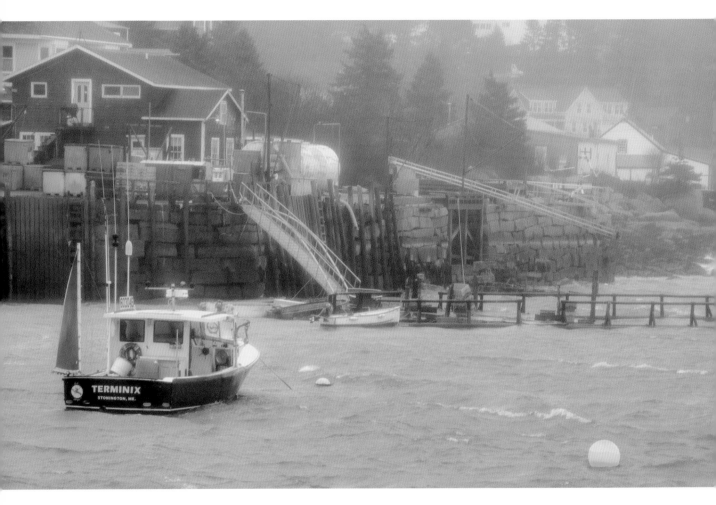

IT'S BLOWING HARD—A WINTER STORM IN STONINGTON, MAINE

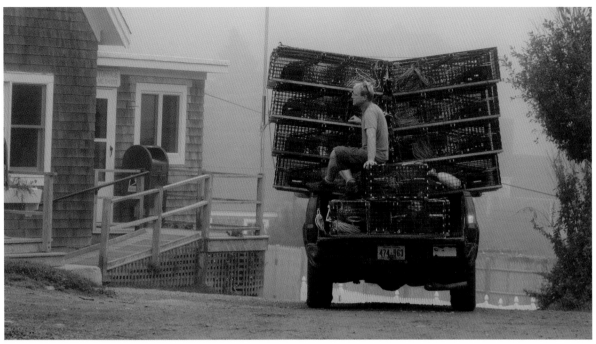

TAKING TRAPS DOWN
TO THE DOCK

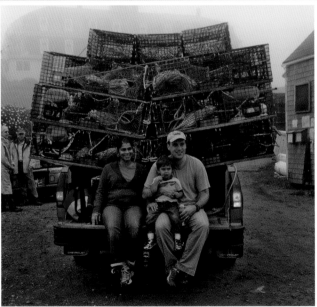

TAILGAITING ON TRAP DAY,
MONHEGAN ISLAND, MAINE

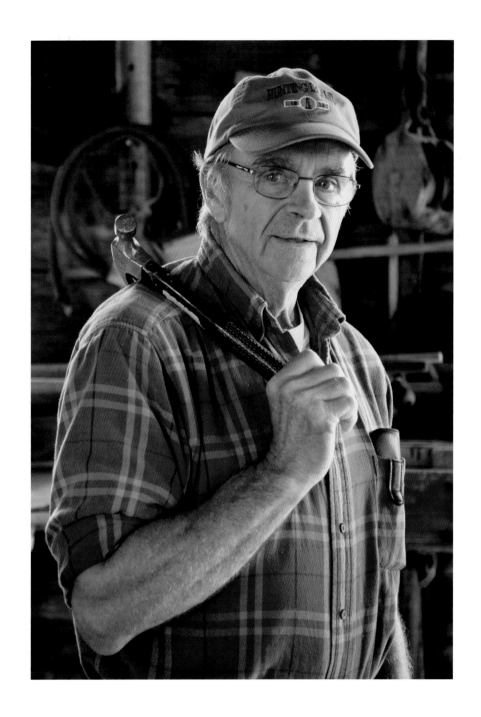

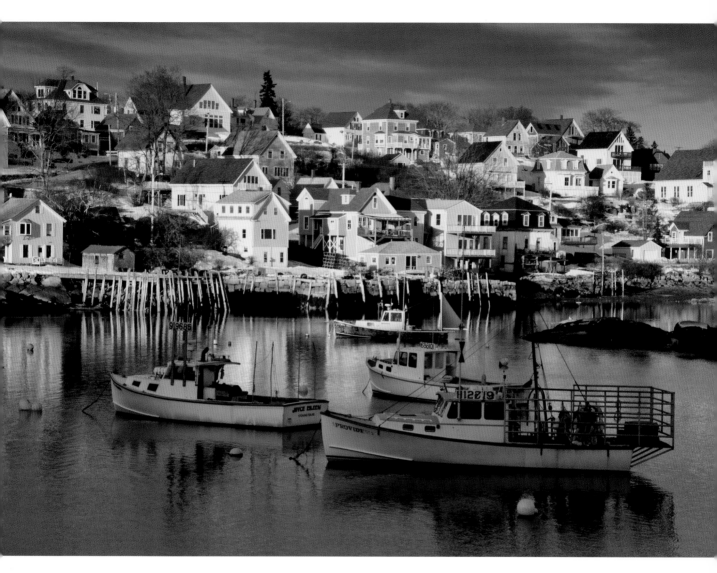

Above: STONINGTON, MAINE

Opposite: A LOBSTERMAN IN HIS WORKSHOP, FRIENDSHIP, MAINE

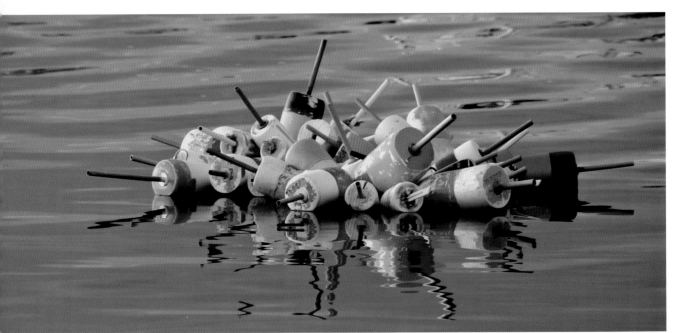

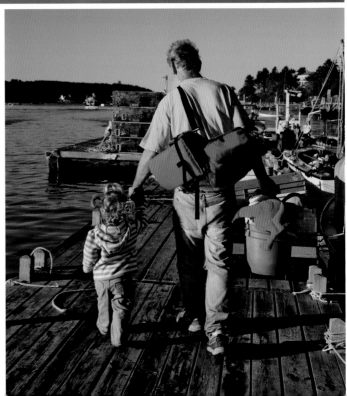

HEADING OUT FOR A DAY OF
LOBSTERING WITH GRANDPA

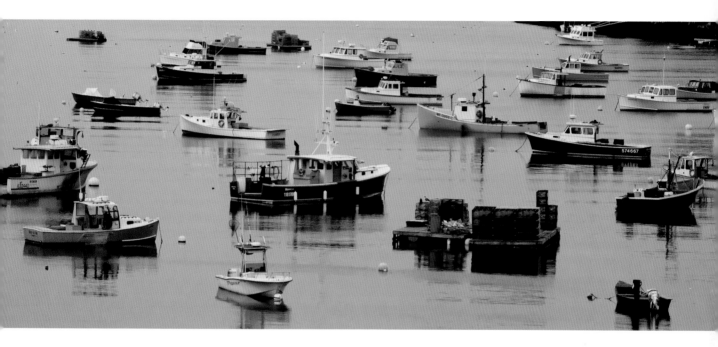

GEAR ON FLOAT, MACKEREL COVE, MAINE

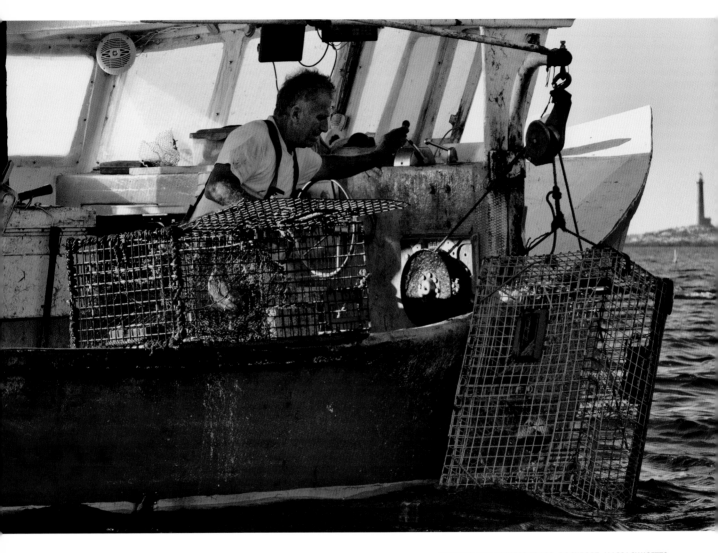

HAULING AND PICKING TRAPS, ROCKPORT, MASSACHUSETTS

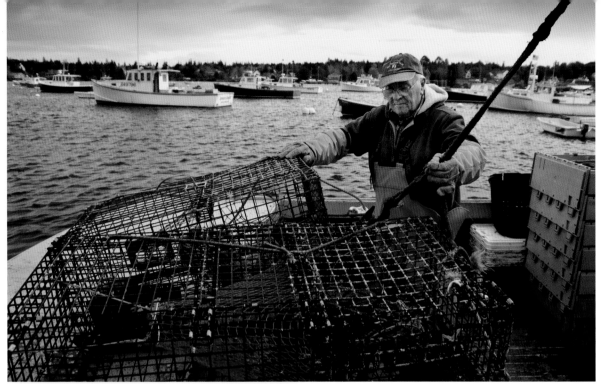

Above: UNLOADING TRAPS ON A STORMY AFTERNOON

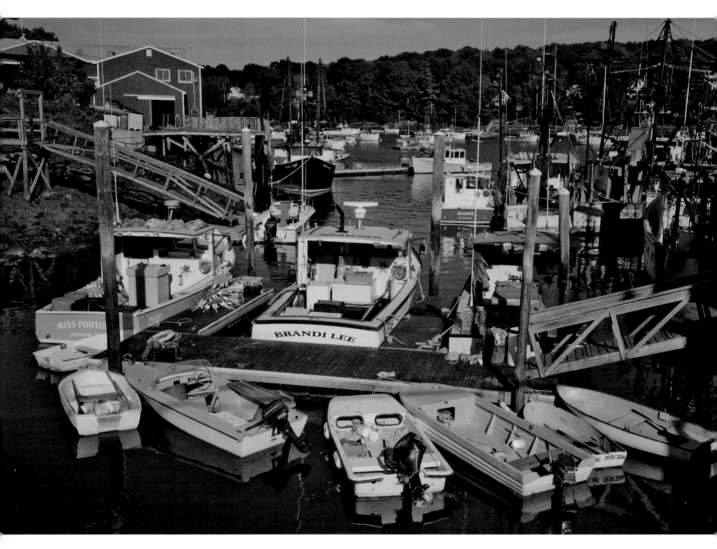

BRISTOL, MAINE

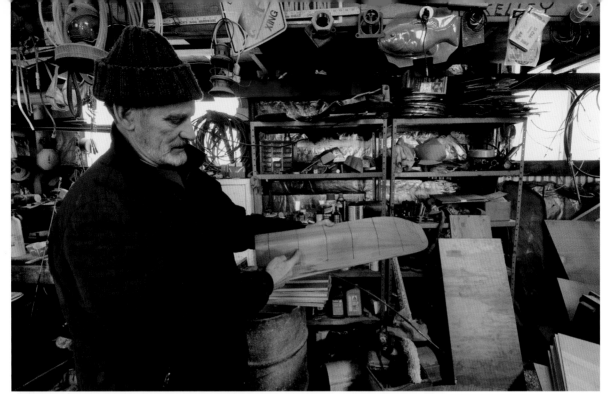

A JONESPORT BOAT
BUILDER WITH A SCALE
MODEL OF HIS NEXT BOAT

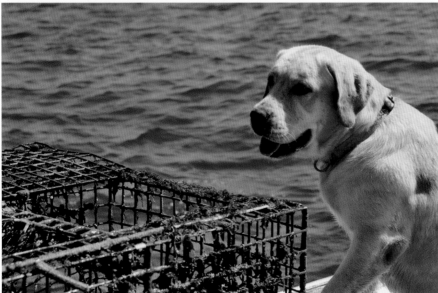

CLYDE THE LOBSTER
DOG STANDS GUARD
OVER THE TRAPS

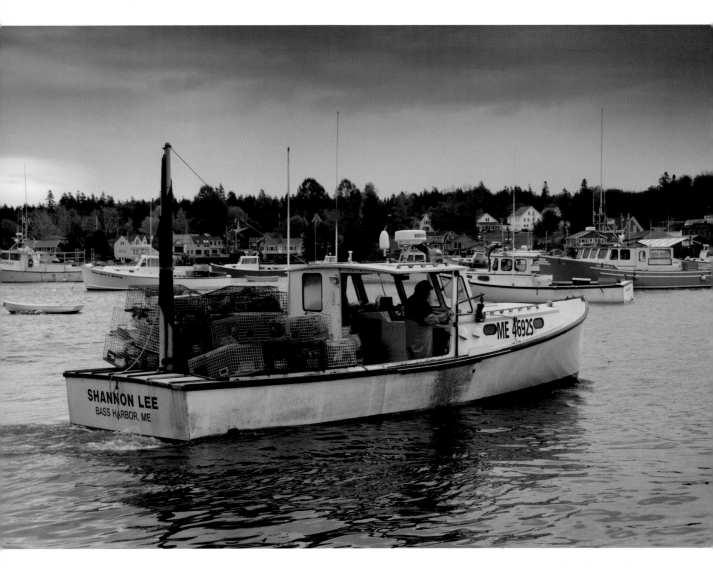

HEADING OUT ON A LATE FALL MORNING, MOUNT DESERT ISLAND, MAINE

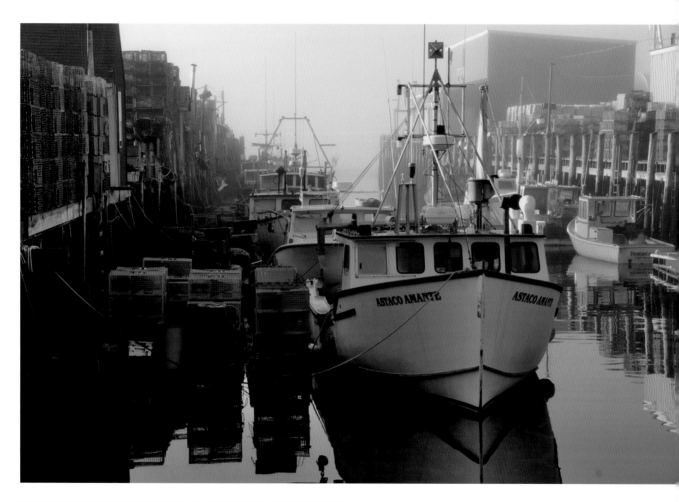

TRAPS AND BOATS READY AND WAITING ON A FOGGY MORNING, PORTLAND HARBOR

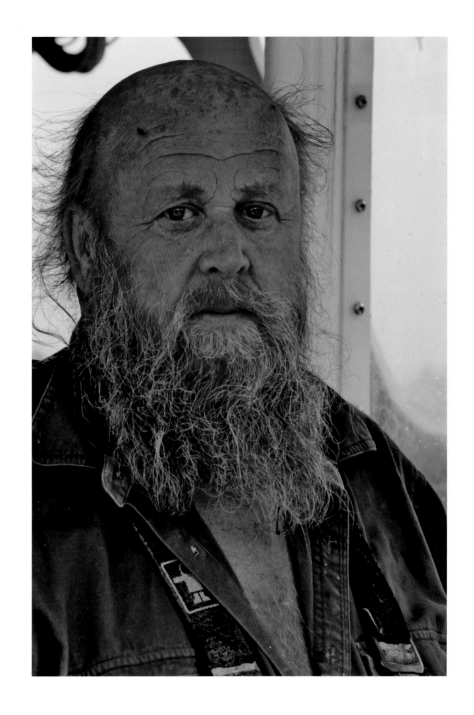

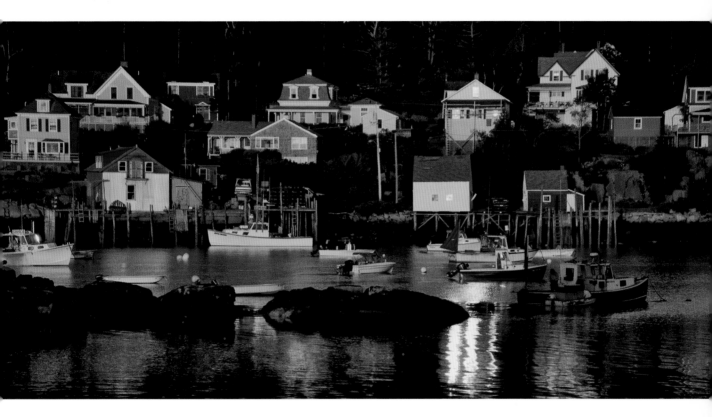

SUNRISE, STONINGTON

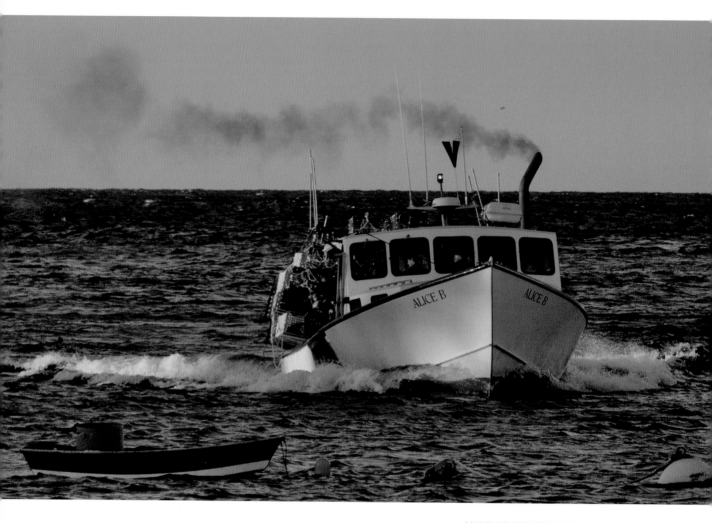

LOADED UP AND HEADING OUT UNDER FULL STEAM

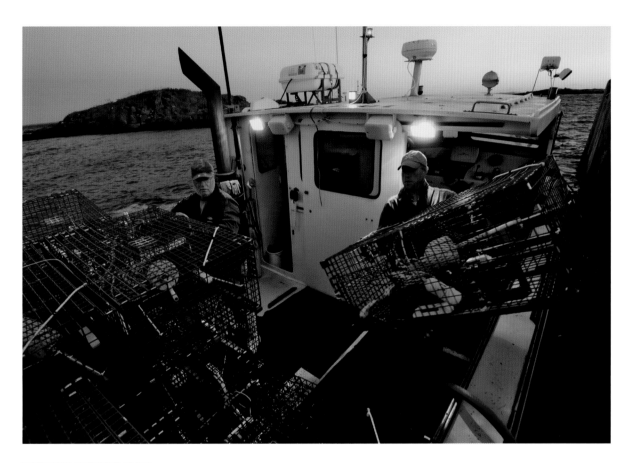

EARLY START, MONHEGAN ISLAND

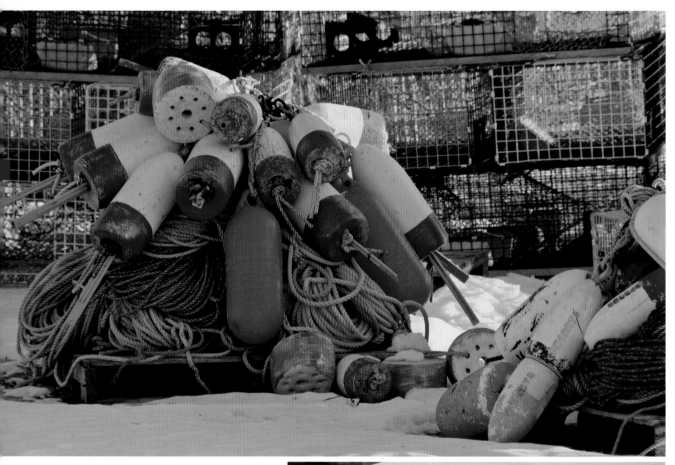

OWLS HEAD HARBOR

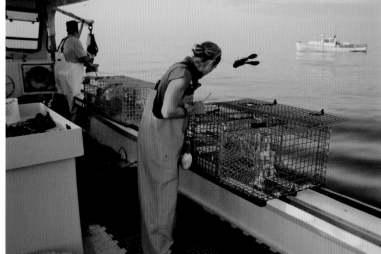

TOSSING THE LITTLE ONES
BACK, PENOBSCOT BAY

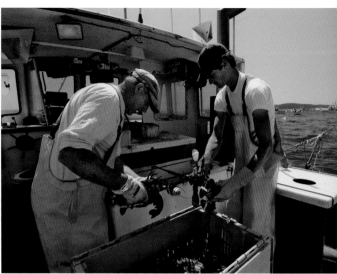

SORTING THE CATCH

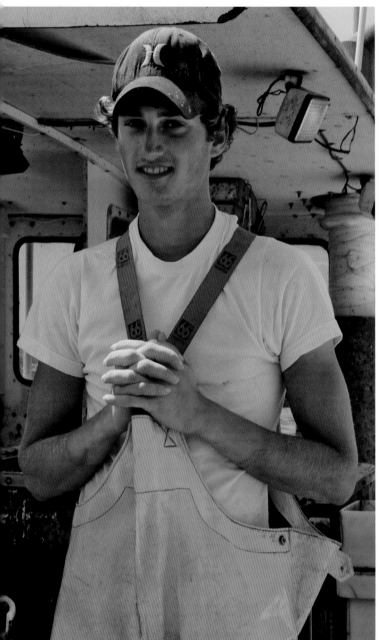

A YOUNG STONINGTON STERNMAN

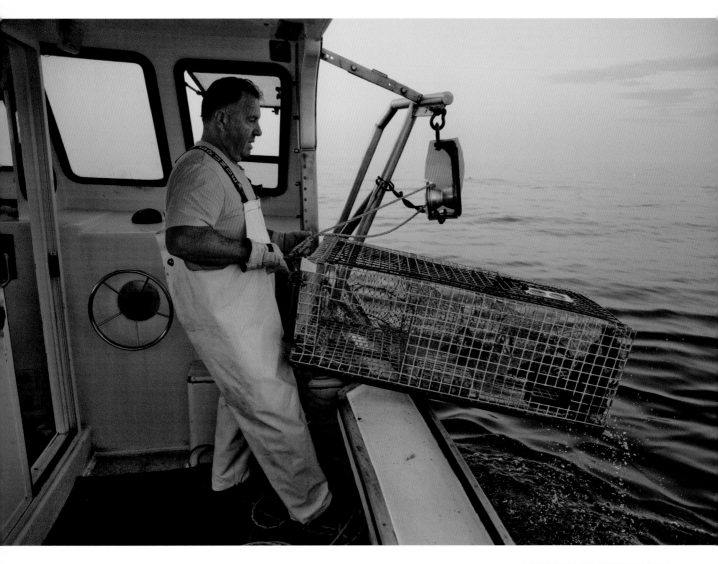

HAULING UP A TRAP, PENOBSCOT BAY

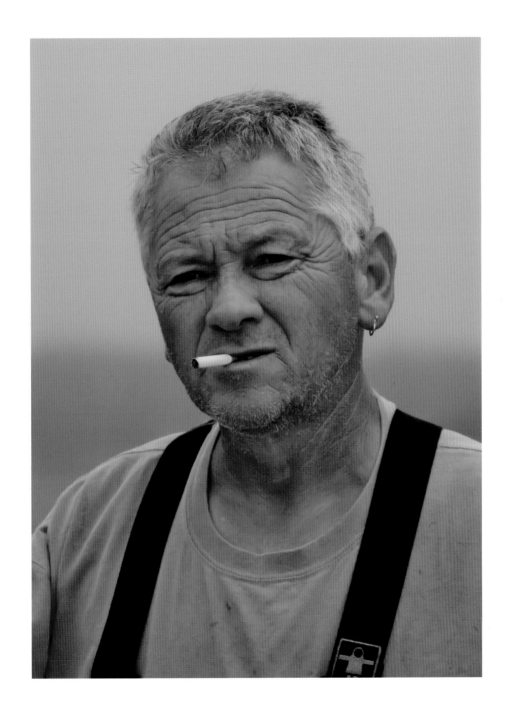

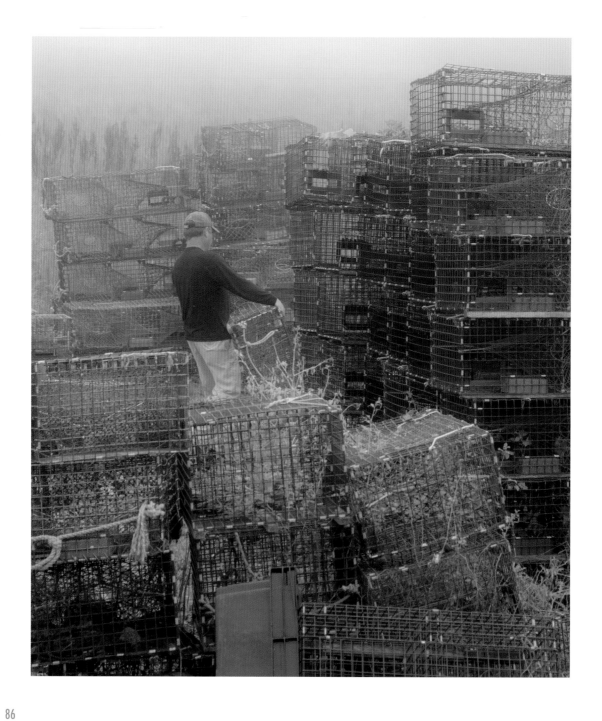

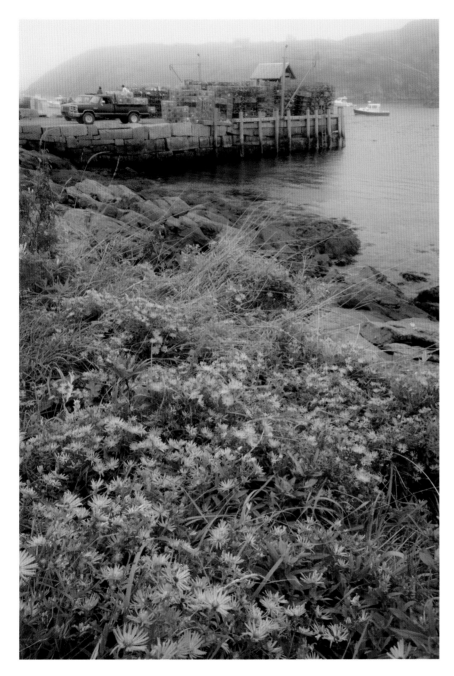

Left: MONHEGAN ISLAND WHARF

Opposite: GETTING READY FOR
THE FIRST DAY OF THE SEASON

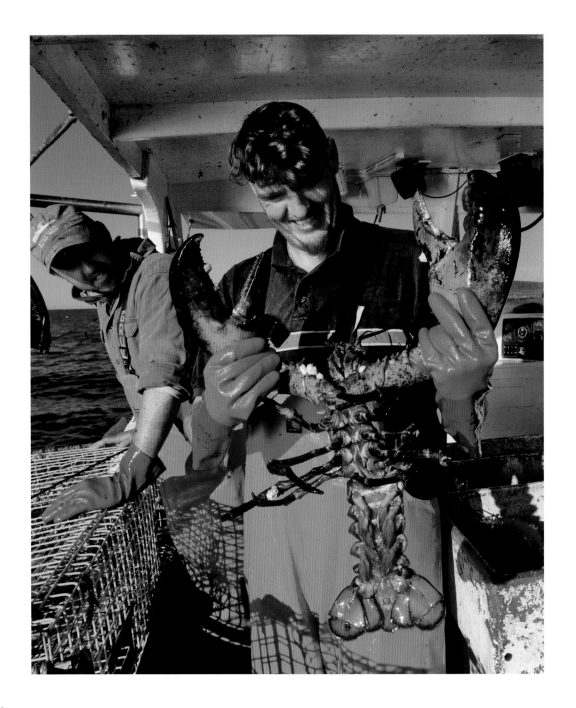

Above: EARLY SUMMER, MAINE

Opposite: THE CREW OF THE *ENDEAVOR* ADMIRE AN OVERSIZED LOBSTER

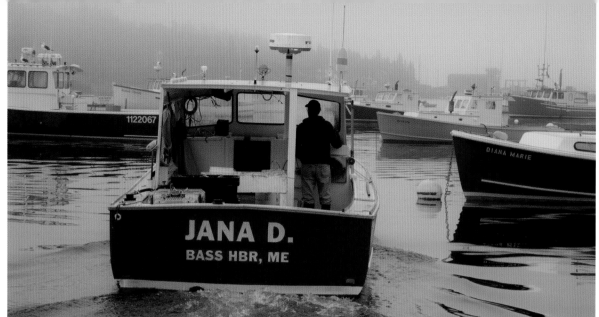

FIRST OUT, BASS HARBOR, MAINE

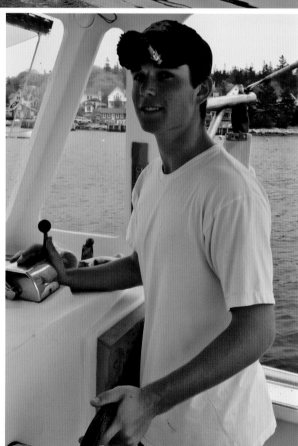

YOUNG CAPTAIN FROM VINALHAVEN

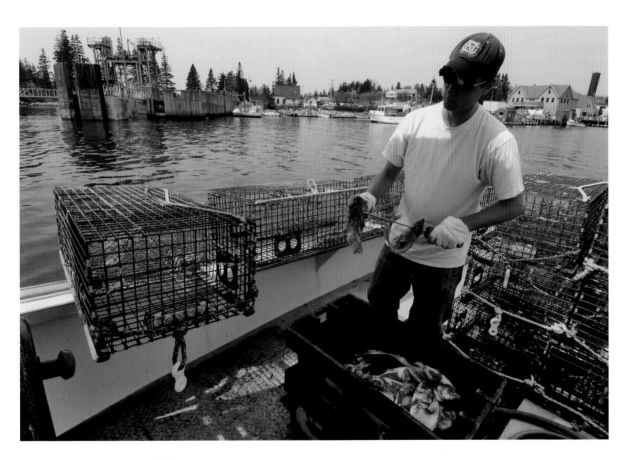

BAITING THE TRAPS, VINALHAVEN, MAINE

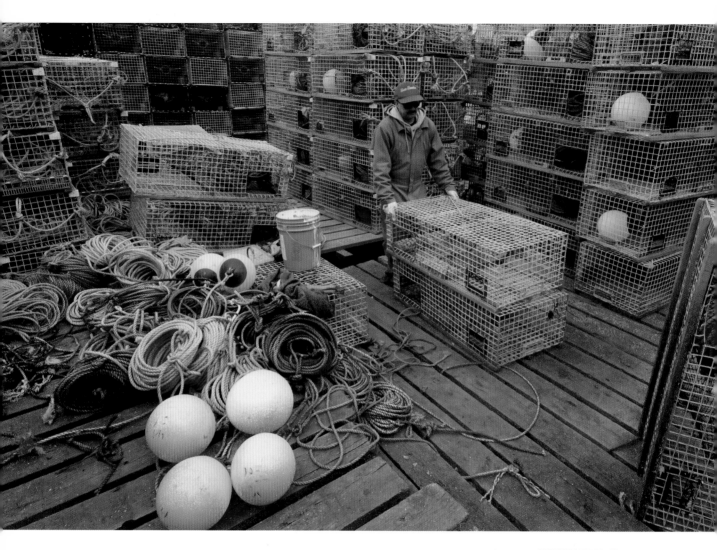

PREPPING TRAPS, COREA, MAINE

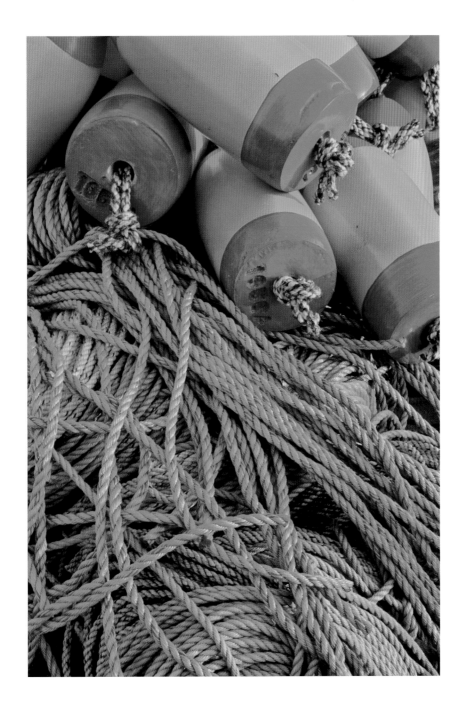

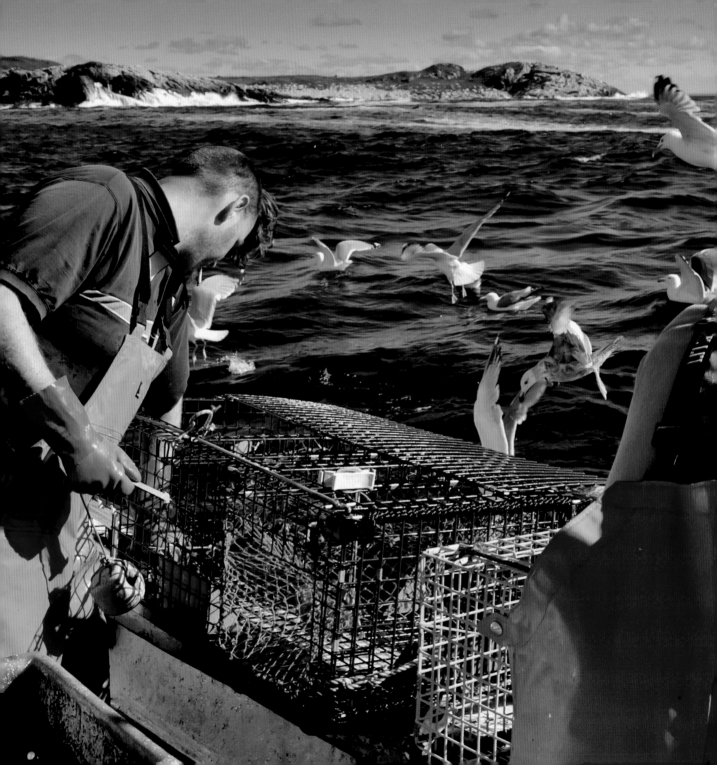

TO CATCH A LOBSTER

IT DOESN'T TAKE MUCH TO CATCH A LOBSTER—a trap, some stinky bait, some line, a buoy, and a boat. Of course, this assumes that you have years of experience on the sea, you know where a lobster is going, and you can drop a trap in its way.

Lobstermen in the Gulf of Maine are allowed to fish 800 traps at once, and each trap must be checked every three days. Traps have two equal-size sections—the *kitchen* holds the bait that attracts the lobsters, and the *parlor* holds the lobsters that get caught. A trap is designed to allow lobsters to travel one way only; netted baffles let lobsters into the kitchen and then into the parlor but not out of the trap. Many lobsters still manage to infiltrate a trap, get a free meal, and not get caught.

Traps are set according to lobsters' migration patterns. In the coldest months lobsters are in deep water, down to 2,300 feet; in the warmest months they're in shallow water, right in the harbors. Lobstermen often relocate their traps, putting them where the lobsters are.

Traps are connected to colored buoys, and the color combination is unique to each lobsterman. In Maine there are usually two traps for each buoy and 3 to 10 buoys, depending on the size of the boat, in a group or patch. In the southern Gulf of Maine, lobstermen usually set trawls, a string of 8 to 12 traps on a line with a buoy at each end.

A lobster boat is "handed" just like a person—a left-handed captain will have a cabin with an open left side where the trap is hauled up, and a right-handed captain will have a boat with an open right side.

The lobsterman grabs the buoy with a long pole. It's then brought on board and the trap line is put over a pulley (known as the *block*) and then around a power winch (the hauler) that pulls the trap up to the boat. The captain then grabs the trap and heaves it onto the 12-inch-wide gunwale (the top edge of the boat) and slides it down to the sternman. The gunwale is topped with metal skid rails and is wide enough to be a stable working platform but narrow enough to fit under a trap.

The sternman opens the trap and cleans out everything inside, throwing the lobsters that are too small (or too big) overboard and tossing the "keepers" onto the sorting table. A keeper has to be the right size, and size is determined using a hand-held tool that measures the lobster's carapace. A lobster can't have any eggs under its tail and it can't have the V-notch that lobstermen cut in the tip of the tail

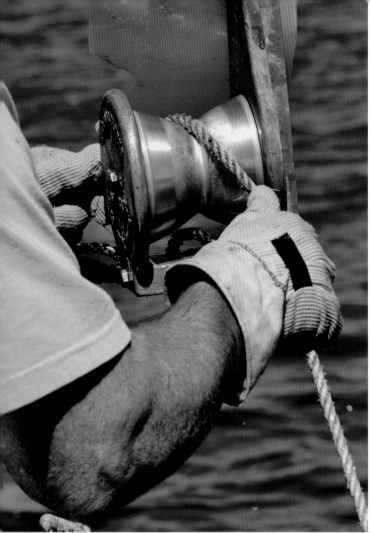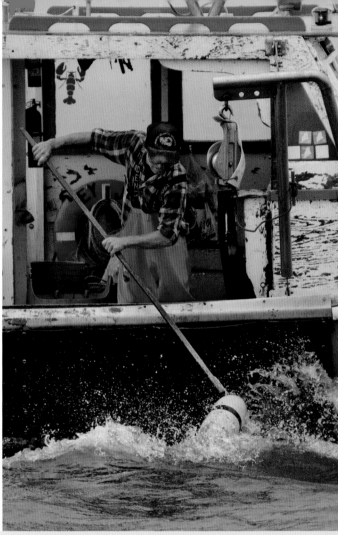

Left: PUTTING THE HAULING LINE
OVER THE BLOCK TO PULL UP A TRAP

Right: GAFFING THE BUOY

in all egg-bearing females they catch. If they catch a female with eggs or a V-notched female, they throw them back to help perpetuate the breeding stock.

The sternman then tosses the old bait overboard, rebaits the traps with fresh dead fish, closes the trap, and stacks it on the stern. When all the traps of a trawl or patch have been hauled, the captain repositions the boat and the sternman pushes the now fresh traps overboard on the captain's command.

As the boat is steaming to the next trawl or patch the sternman puts thick rubber bands around each lobster's claws and drops the lobster into a water-filled

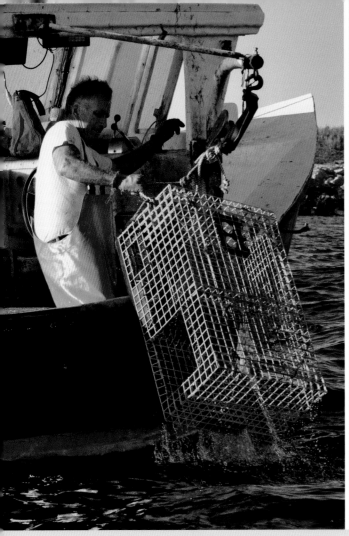

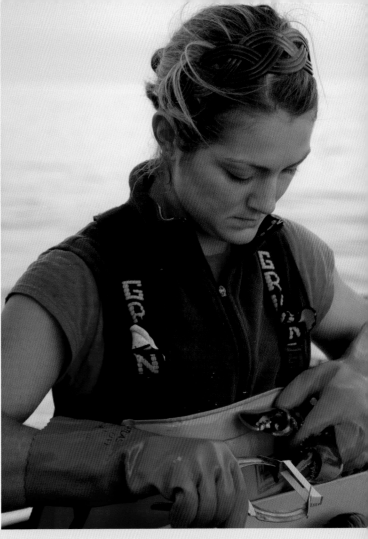

holding tank. He or she then refills the baiting tool, grabs more bait, and quickly tidies up the deck. Depending on the size of the catch, the captain will also help with the picking and cleaning of the traps.

In late summer off the Maine coast, a trap will typically contain 4 to 8 under-sized lobsters, 2 to 8 keepers, 1 or 2 eggers or V-notched females, 10 to 12 crabs, and various fish by the time a boat returns to check the line. A catch of 1,000 pounds' worth of lobsters is a good day in Maine waters; 400 pounds is a good day in southern Gulf waters.

Left: IT'S HARD WORK
BRINGING A TRAP ON BOARD

Right: A STERNMAN PUTS RUBBER
BANDS AROUND THE CLAWS

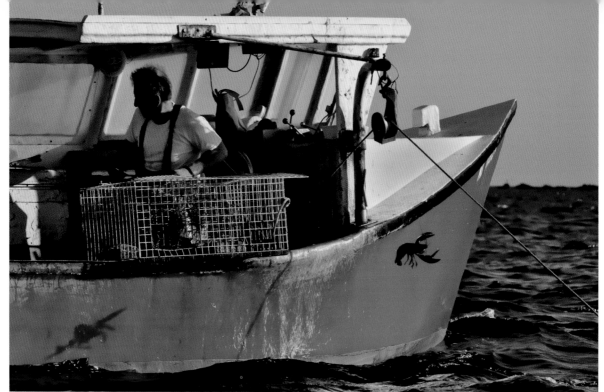

A LITTLE ONE GOES BACK INTO THE
WATER OFF ROCKPORT, MASSACHUSETTS

FORKING BAIT

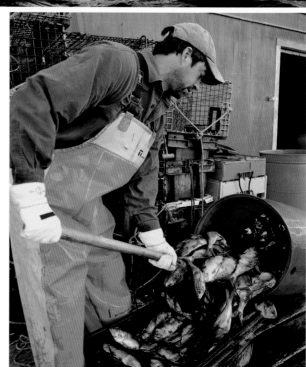

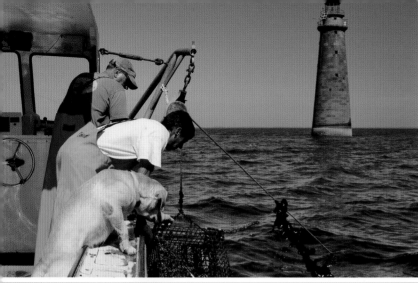

Left: IT TAKES THE WHOLE CREW
TO BRING IN THE CATCH

Below: A KEEPER GOES INTO THE HOLDING TANK

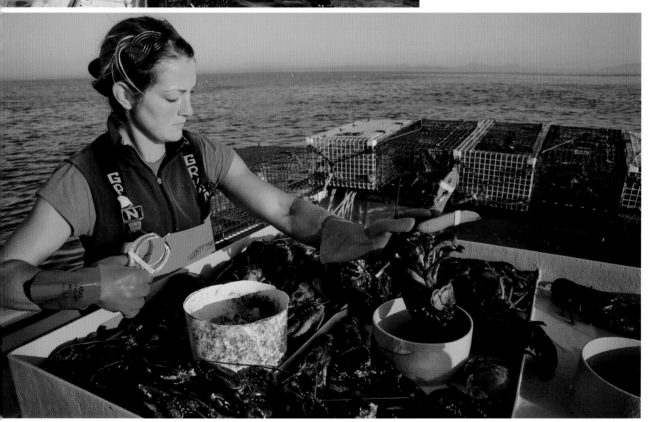

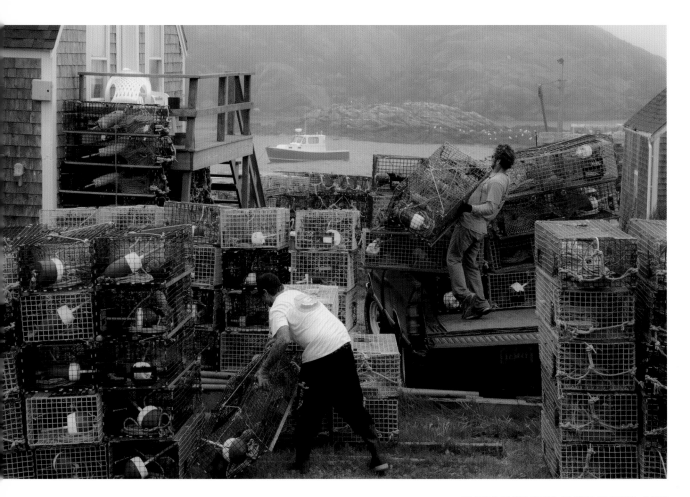

LOADING UP THE TRUCK, MONHEGAN ISLAND, MAINE

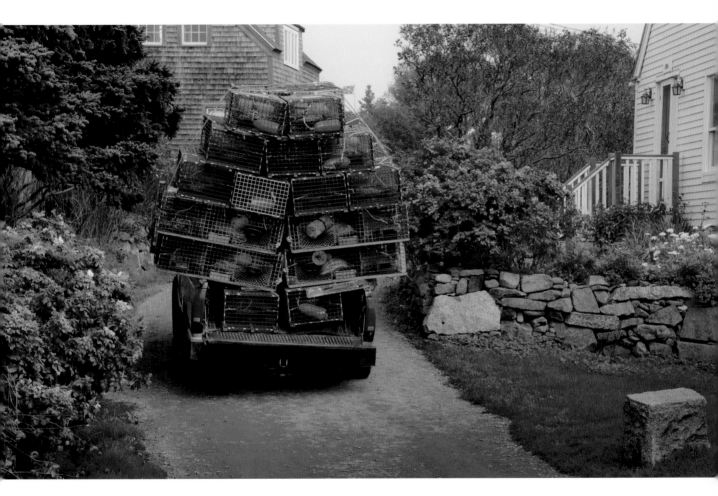

ROLLING DOWN MAIN STREET

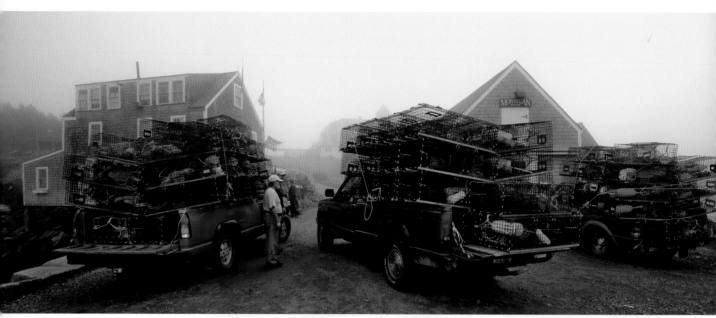

RUSH HOUR ON THE
WHARF, MONHEGAN
ISLAND, MAINE

HUNG OUT TO DRY

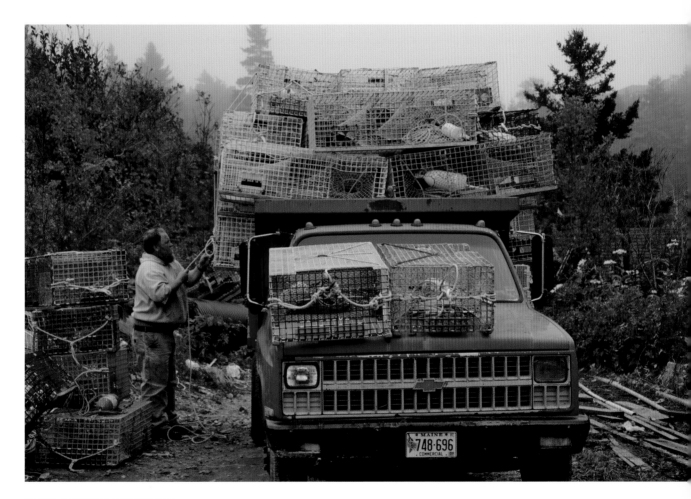

THERE'S ALWAYS ROOM FOR ONE MORE

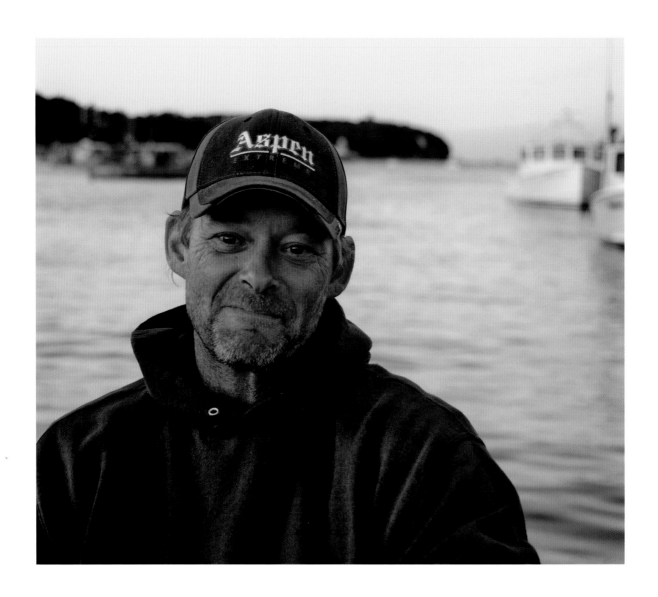

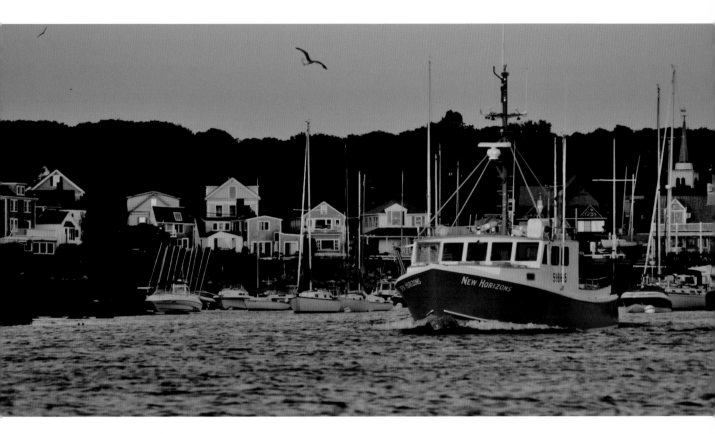

FIRST LIGHT, CAPE ANN, MASSACHUSETTS

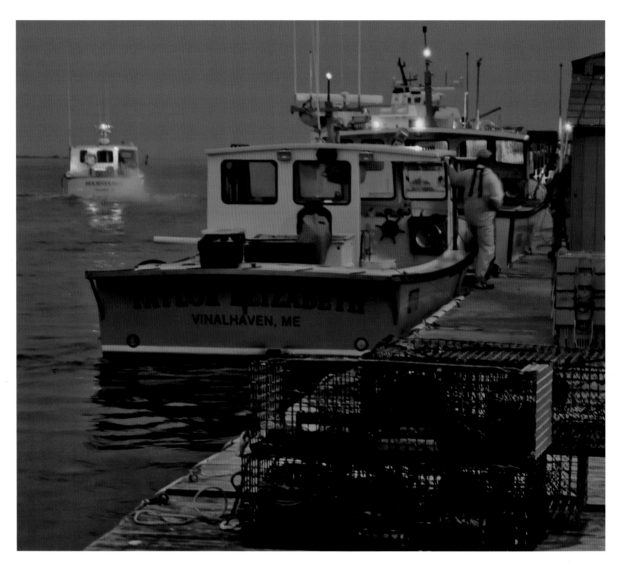

4 AM AT THE FUEL DOCK, VINALHAVEN, MAINE

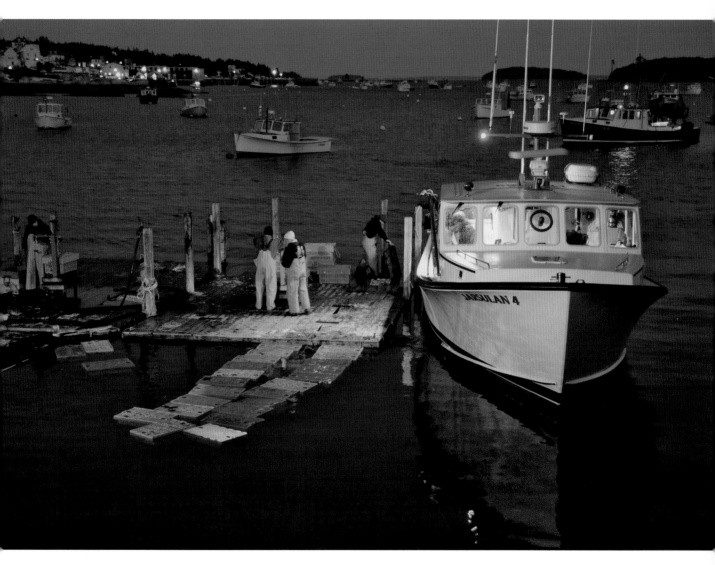

UNLOADING THE CATCH AFTER A LONG DAY OUT, STONINGTON, MAINE

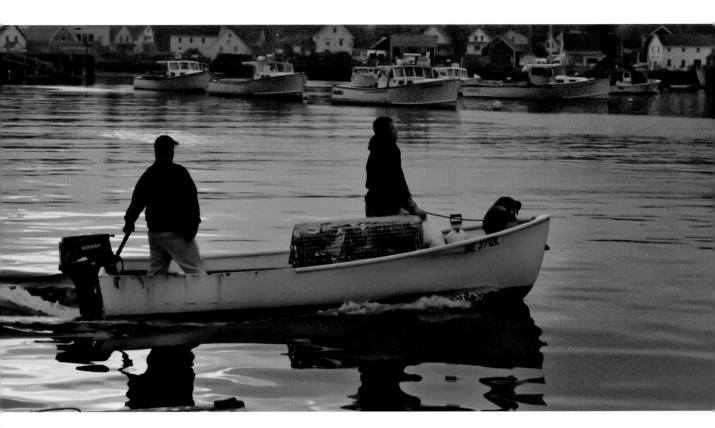

HEADING TO THE BOAT, DOG AND ALL

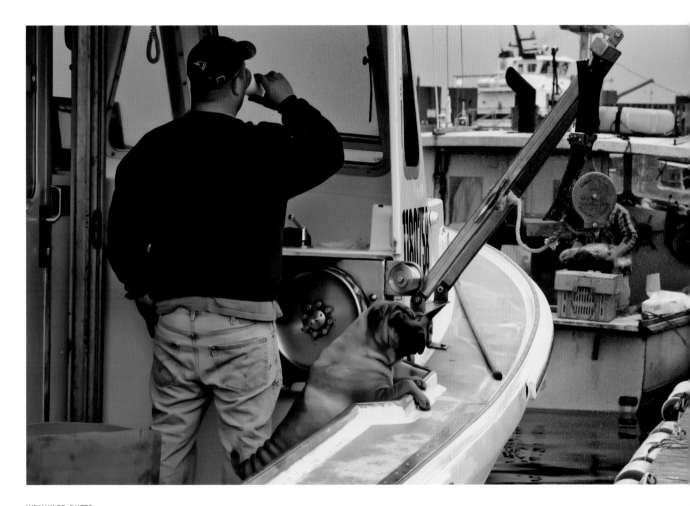

WRINKLED BUTTS

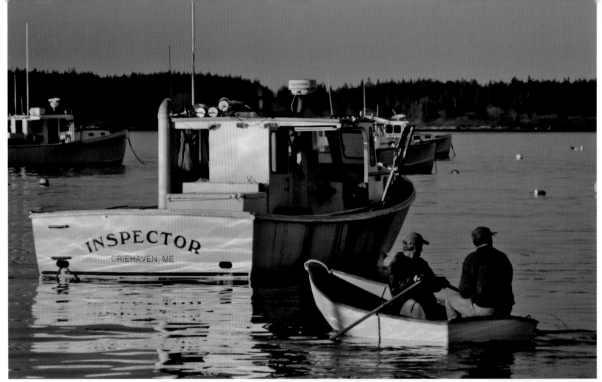

THE MORNING COMMUTE

"MAWNIN'" IN
PORTLAND, MAINE

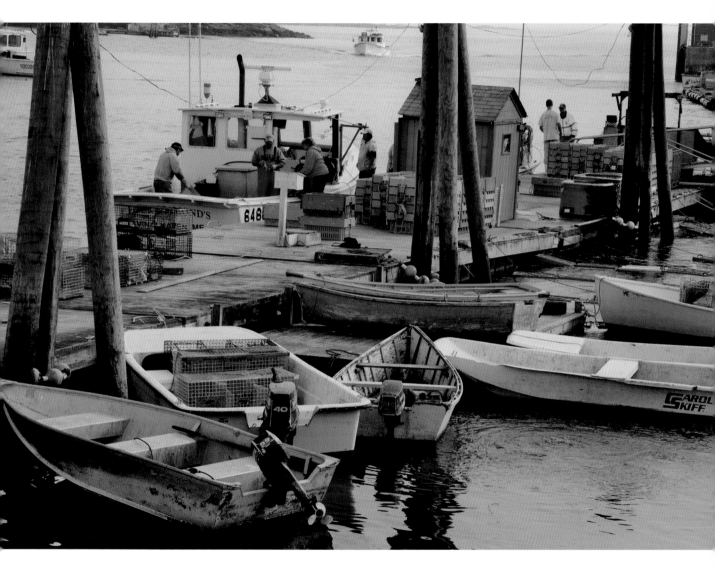

THE FUEL DOCK, VINALHAVEN, MAINE

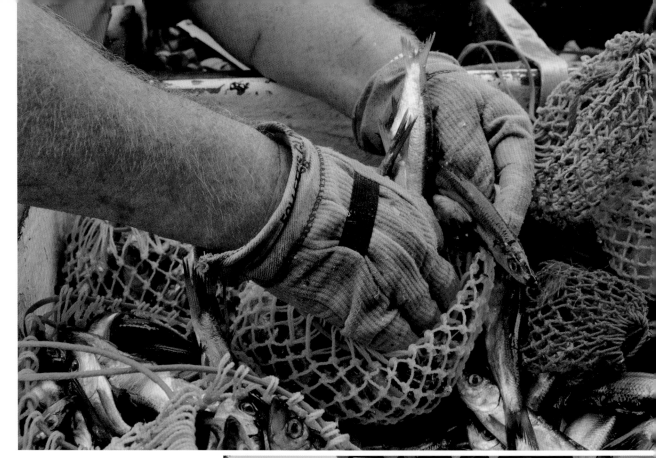

LOADING BAIT
BAGS WITH HERRING

IT'S A LONG REACH
TO GET THE LAST LOBSTERS
IN THE HOLDING TANK!

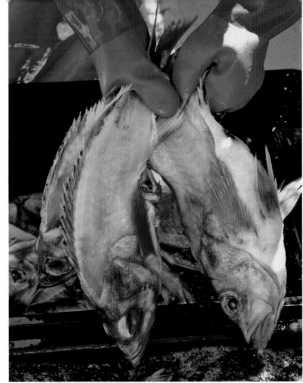

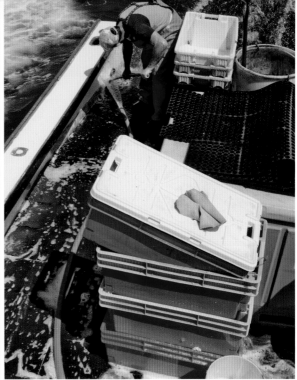

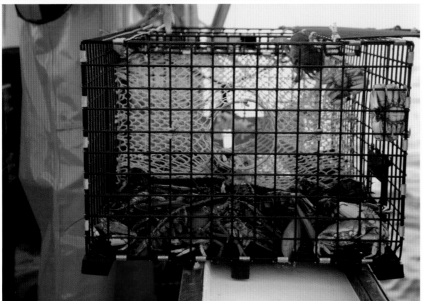

Above left: GRABBING BAIT
FROM THE THAWING TANK

Above right: SCRUBBING THE
BOAT CLEAN ON THE WAY HOME

Below left: A TRAP FRESH
OUT OF THE WATER

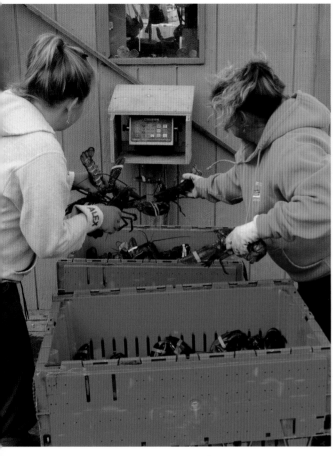

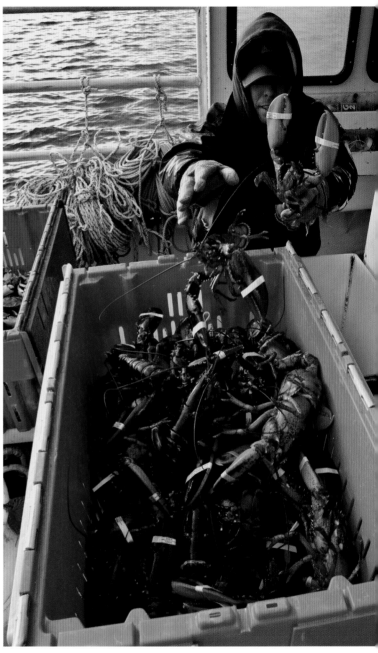

Above: WEIGHING IN

Right: UNLOADING THE CATCH

Opposite: A COHASSET CAPTAIN AT THE HELM

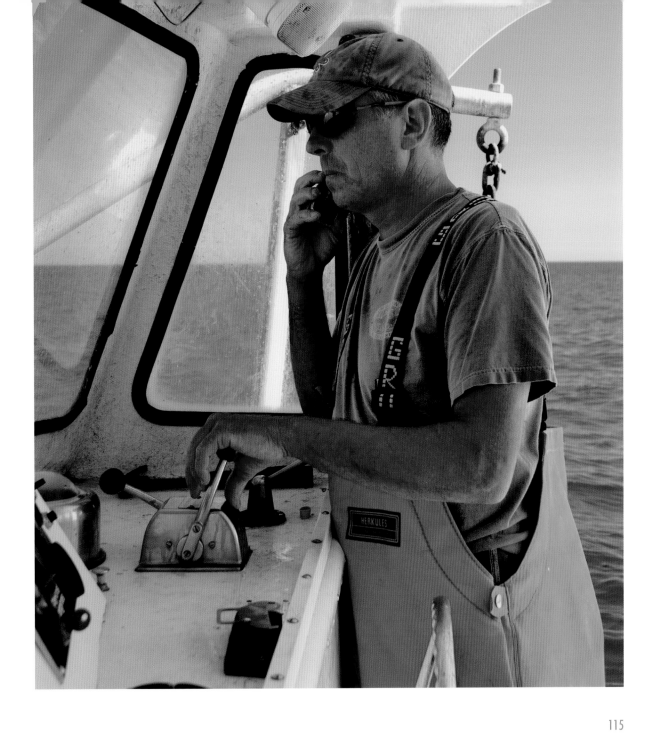

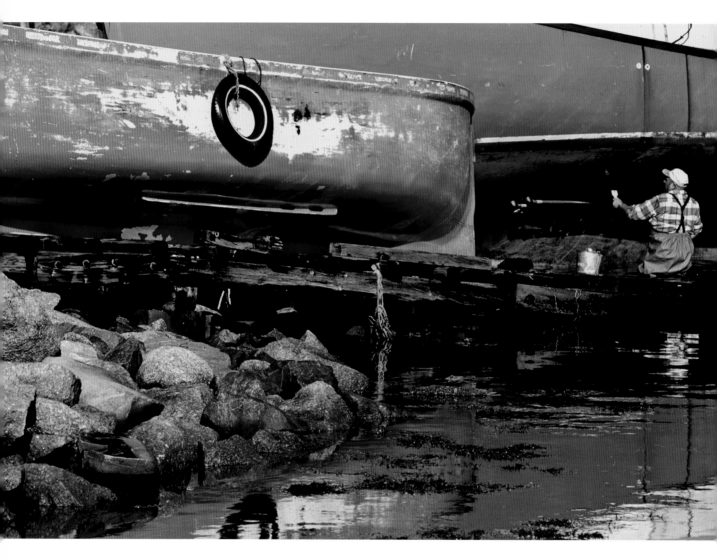

LATE-SUMMER REPAIRS, YARMOUTH, NOVA SCOTIA

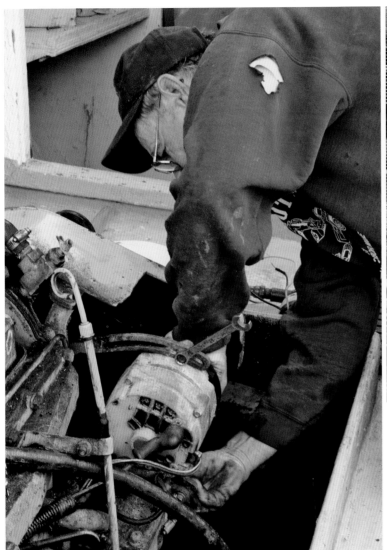

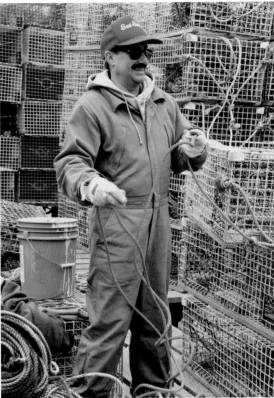

THERE'S ALWAYS WORK TO
BE DONE, EVEN IN WINTER

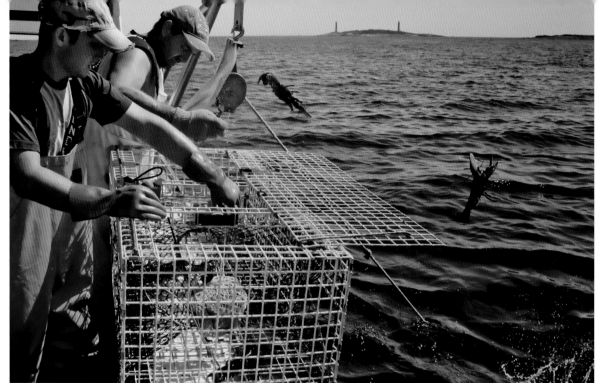

Above: SEARCHING FOR
KEEPERS OFF TWIN LIGHTS

Right: TOSSING BACK THE LITTLE ONES,
ROCKPORT, MASSACHUSETTS

Opposite: CAPTAIN OF THE *ENDEAVOR*
SHOWING OFF AN OVERSIZED LOBSTER

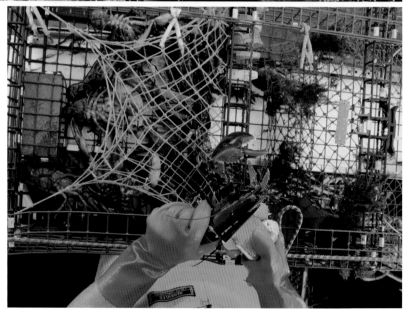

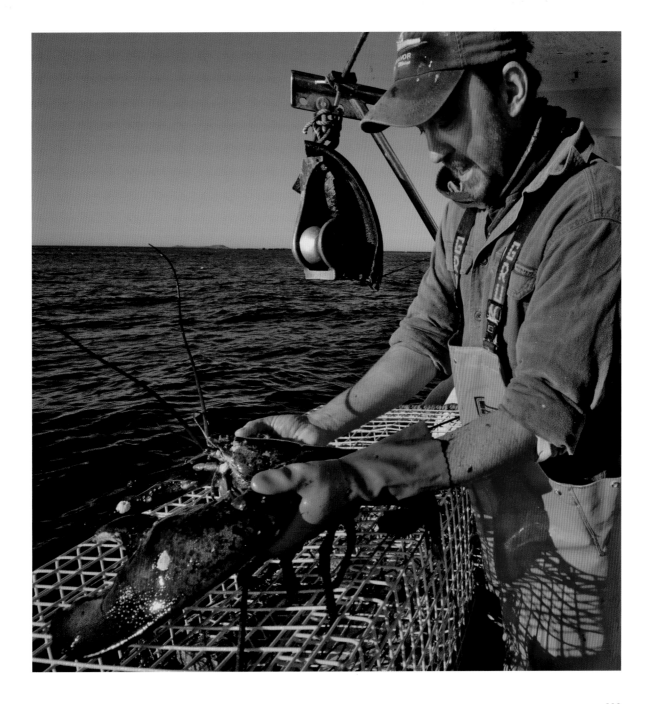

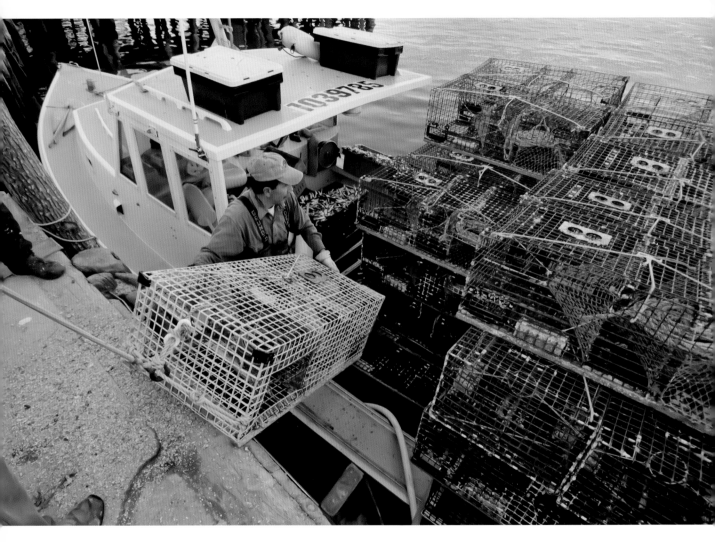

HOW TO FIT 80 TRAPS ON A LOBSTER BOAT

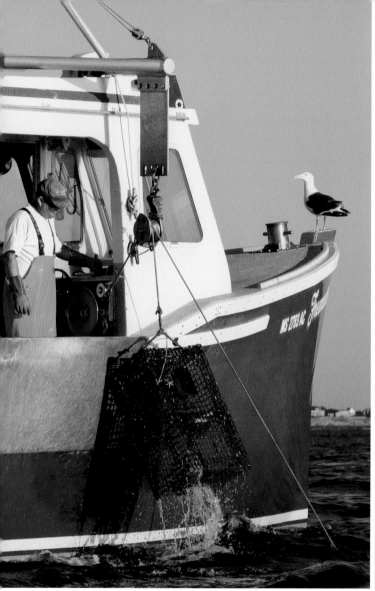

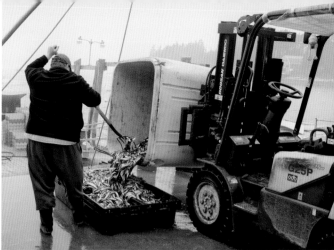

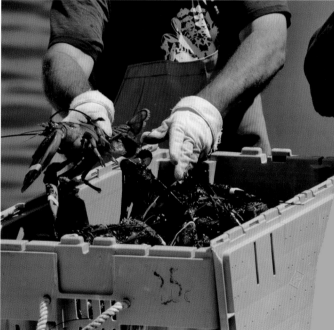

Above left: A FIRST LOOK AT THE CATCH, GLOUCESTER, MASSACHUSETTS

Above right: UNLOADING BAIT FOR THE BOATS

Below right: UNLOADING THE DAY'S CATCH

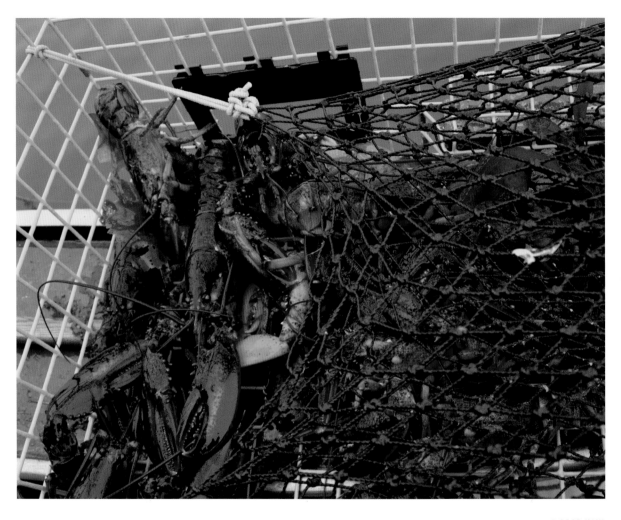

A GOOD HAUL

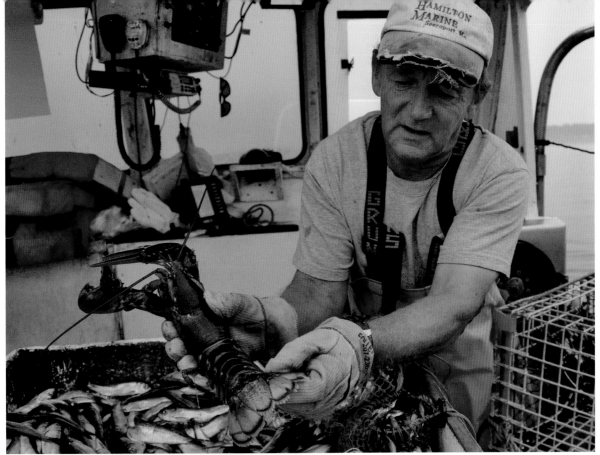

BASS HARBOR CAPTAIN
WITH A V-NOTCHED FEMALE

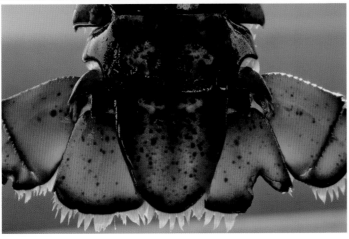

A V-NOTCH ON THE TAIL
INDICATES A BREEDING FEMALE

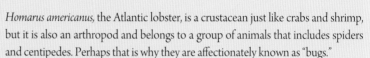

LOBSTER FACTS

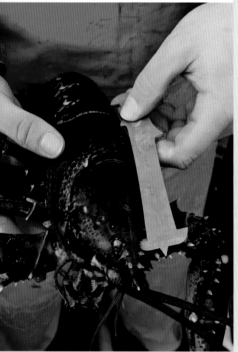

Homarus americanus, the Atlantic lobster, is a crustacean just like crabs and shrimp, but it is also an arthropod and belongs to a group of animals that includes spiders and centipedes. Perhaps that is why they are affectionately known as "bugs."

Lobsters live as far south as North Carolina and as far north as Labrador, but they are most abundant in the Gulf of Maine. They can live in shallow water of just a few feet, or in water over 2,000 feet deep.

In late spring and early summer lobsters migrate inshore, to warmer waters, and in late summer and early fall they migrate back out to deeper waters, which stay warmer in winter.

Lobsters have been commercially fished for about 150 years. A century ago they were used as cheap food for indentured servants and prisoners. The law even forbade feeding lobster to prisoners more than three times a week. Lobsters were also ground up and used as fertilizer.

It takes a lobster six or seven years to reach legal size. To estimate a lobster's age, multiply its weight by 4 and add 3. So a 3-pound lobster is about 15 years old.

Lobsters start out as tiny larval creatures that float on ocean currents. They begin shedding right away and, after a month or so, they resemble miniature lobsters no bigger than your fingernail. At this point they drop to the ocean floor and look for a suitable home in which to eat, grow, and hide from predators.

Lobsters must shed their exoskeletons in order to accommodate growth. The lobster uses hydraulic pressure to split its exoskeleton in half and then crawls out, a soft and unprotected "shedder." On average, a lobster will shed once a year and its weight increases by half with each shed. As a lobster ages, it sheds less often.

Shedding is hard work. When a lobster sheds, it has to pull all its flesh out of and away from its shell. The lobster's teeth are located inside its stomach cavity and are part of its exoskeleton. Therefore, the teeth must be pulled up from the inside of the lobster's stomach and out through its mouth. It also has to pull its claw flesh out through its tiny little wrist joints. Lobsters might even die trying to shed.

Not only does shedding facilitate growth, it also allows for mating. The female must shed before the male can mount her newly soft body. The male lobster is a

Above: ONLY ONE LOBSTER
IN SEVERAL MILLION IS BLUE

Below: MEASURING FOR LEGAL SIZE

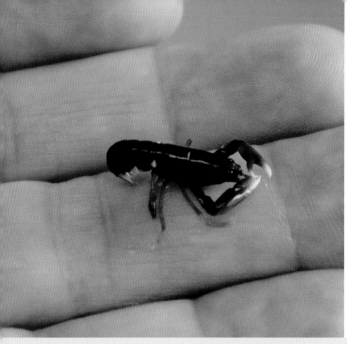

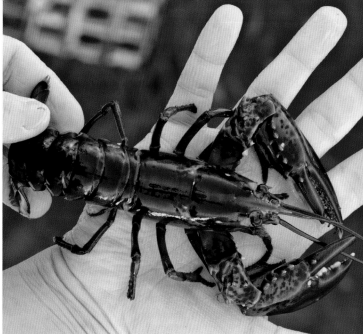

tender lover, caressing the female all over with his antennae before gently rolling her onto her back and using his two swimmerets to deposit his packet of sperm.

The female lobster will wander the ocean floor, carrying her mate's sperm, until she decides the conditions are right to fertilize her eggs. She can also jettison the sperm packet of her last suitor if a better male comes along. A female carrying eggs under her tail is called an "egger" or a "berried" female and must be returned to the water if caught.

A "V-notched" lobster is a female that has had a *V* cut into a fin on the right side of her tail to identify her as part of the breeding stock. It is illegal to keep or sell a V-notched female.

A mature female can produce tens of thousands of eggs. She carries the eggs for nearly a year, until the larva hatch out into the water.

Lobsters are opportunistic feeders but they prefer urchins, crabs, and, of course, stinky bait.

Underwater cameras have shown that lobsters can in fact move in and out of traps—some even appear to guard traps. The lobsters caught on any given day are the ones snacking at the wrong moment.

Lobsters find food and mates primarily through their sense of smell—they flick a pair of antennules through the water to pick up scents.

Lobsters are "handed," just like people and lobster boats. They start out

Left: TWO MONTHS OLD

Right: A YOUNG LOBSTER

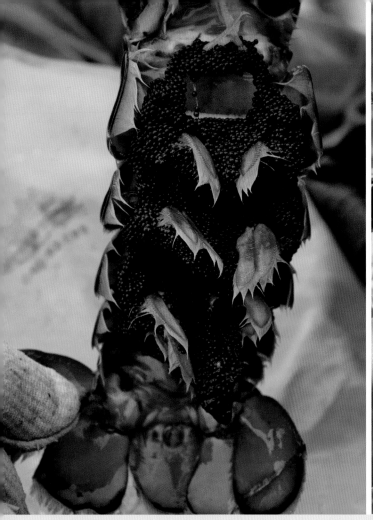

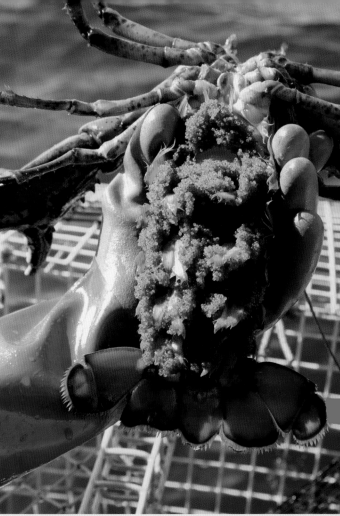

Left: FRESH EGGS ON A FEMALE

Right: A FEMALE CARRYING
LATE-STAGE EGGS

ambidextrous and then, as they age, they develop a powerful crusher claw and a quicker pincer claw.

When two lobsters have an argument that cannot be settled with a few jabs and knocks on the head, they will engage in something akin to arm wrestling by clasping each other's crusher claws. No lobster wants to lose a crusher claw so, in most cases, one will retreat.

If a lobster does lose a claw in battle or when shedding, it will grow back over time.

Lobsters have blood, but they do not have veins and arteries; instead, the blood

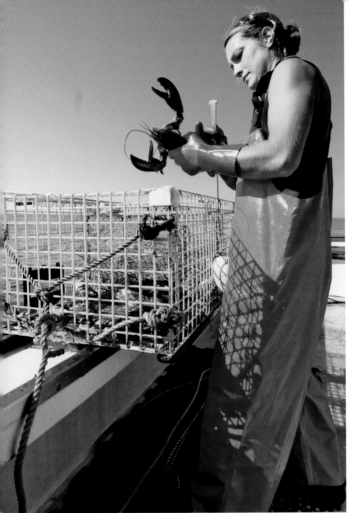
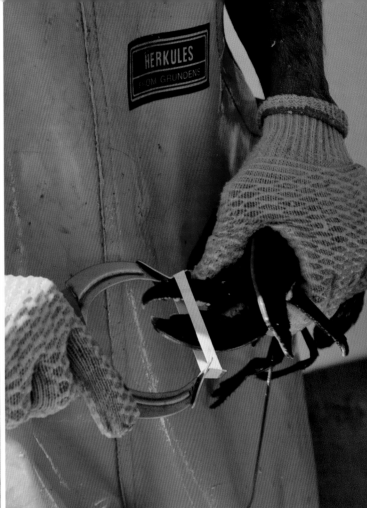

Left: INSPECTING THE UNDERSIDE
OF A LOBSTER FOR EGGS

circulates freely in their body cavities. They possess a rudimentary brain as well, similar to that of a grasshopper.

Most lobsters are blackish green when pulled from the water. They also come in other colors—yellow, orange, half and half, calico, and, very rarely, blue. Ghostly white albino lobsters are the rarest. All lobsters, except albinos, turn red when you cook them because the heat used in cooking breaks down the outermost layer of proteins in the shell to reveal the red pigment that is present underneath.

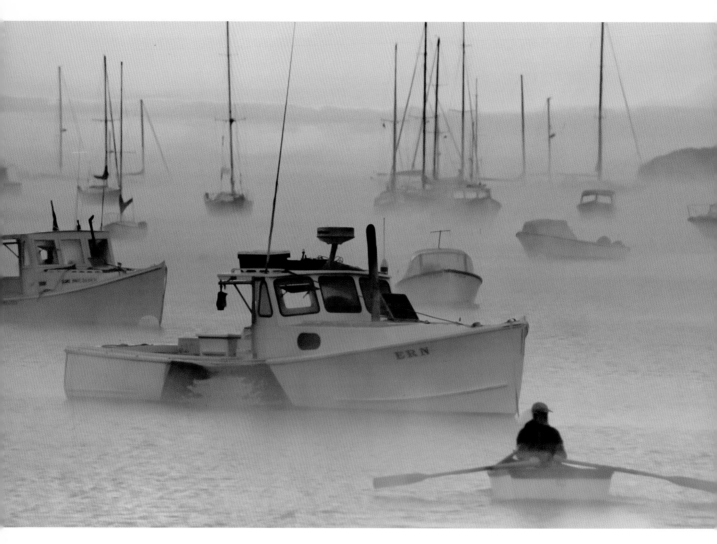

EARLY MORNING, ROCKPORT HARBOR, MAINE